IMAGES
of America

POINT LOBOS

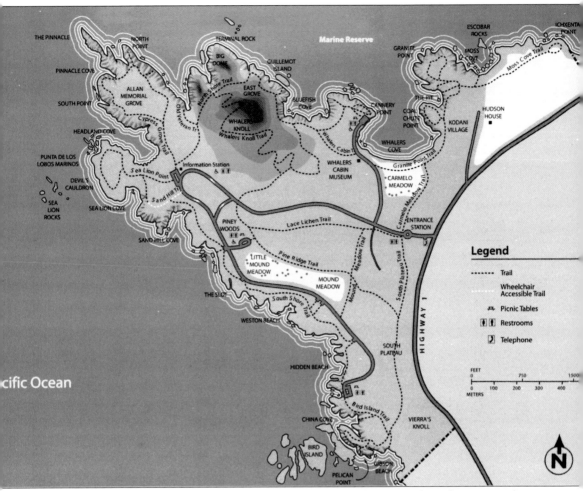

The Pacific Ocean

Legend

-------- Trail

Wheelchair Accessible Trail

Picnic Tables

Restrooms

Telephone

For over 100 years people have appreciated the beauty of Point Lobos, that extraordinary conjunction of land and sea that produces great awe and joy in observers. This map shows the geographic layout of the reserve: hills, coves, headlands, islands, beaches, and trails. It gives no hint of the beauty that awaits visitors as they enter the reserve. (Map by Jeff Thomson of Walkabout Publications.)

Cover photo by A.M. Allan.

IMAGES
of America

POINT LOBOS

Monica Hudson
Suzanne Wood

ARCADIA
PUBLISHING

Published by Arcadia Publishing
Charleston, South Carolina

Printed in the United States of America

Library of Congress Catalog Card Number: 2004108142

For all general information contact Arcadia Publishing at:
Telephone 843-853-2070
Fax 843-853-0044
E-mail sales@arcadiapublishing.com
For customer service and orders:
Toll-Free 1-888-313-2665

Visit us on the Internet at www.arcadiapublishing.com

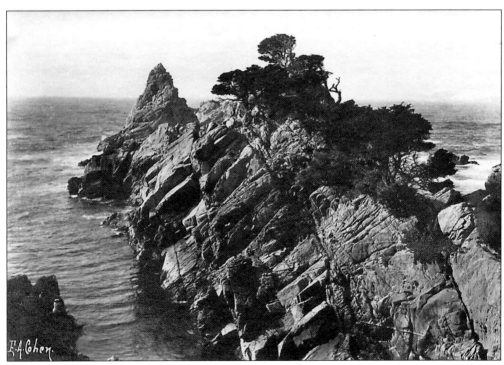

Pinnacle Point at Cypress Grove is one of the most dramatic sights in the reserve at Point Lobos. This picture was taken around the turn of the 20th century by Edgar A. Cohen, a California landscape photographer. (Allan family collection.)

CONTENTS

ACKNOWLEDGMENTS

We are very grateful for the help of many people in preparing this book. Members of the Allan and Kodani families shared their photos and memories. The reminiscences of Kuni Kodani, who grew up in the Japanese village, and Marilyn Kodani's family memories were of great help in creating a picture of life at Whalers Cove. Mary Riley Whisler, Allan family historian, was of invaluable help and generously shared her collection of old photographs. She, her sister Betty Riley Wilson, and Allan Hudson contributed their recollections of growing up on the ranch, and helped identify and date many of the photographs. Bruno Odello talked to us about his Bay School experiences. John Hudson spent long hours sorting through the Hudson family picture box from which many long-forgotten photographic treasures emerged. His interest in the technical aspects of the various industrial operations and his comprehensive knowledge of the ranch were of immense help.

This project would not have occurred without the inspiration and encouragement of Kurt Loesch, Point Lobos historian. It was he who felt that there were enough historical photos of Point Lobos to create a book such as this. His collection, donated to the Henry Meade Williams Local History Department at Harrison Memorial Library in Carmel, California, formed the nucleus from which this book evolved. We thank librarian Denise Sallee for her support and assistance.

Individual photographs came from Craig Barth, Jeff Haferman, Charlotte Boyd Hallam, Monica Hudson, Mariam Melendez, Jeannette Otter, Lana Price, Tey Roberts, Gull-Britt Rydell, Harold Short, Gina and Kim Weston, and Cynthia Williams. The Bancroft Library, University of California at Berkeley, California State Parks, Pacific Grove Museum of Natural History, and the Pat Hathaway Collection allowed us to use photographs. Professional photographers Robert Blaisdell, Roger Fremier, Richard Garrod, and Jerry LeBeck generously provided their photographs. Park ranger Chuck Bancroft contributed many of his slides of park activities in the last thirty years. Retired ranger Jerry Loomis gave us the underwater pictures and Jud Vandevere shared stories of his past as a naturalist.

We want to thank Dennis Copeland of the Monterey Public Library for his advice and assistance throughout the process, and for his help in making available to us photographs in his library's collection. Elliot Ruchowitz-Roberts and Lindsey Jeffers were instrumental in acquiring permission to reproduce a prose passage by Robinson Jeffers. Randy Reed of Antique Auto Restoration identified the old cars. Special thanks are due to Neil Hotelling of Pebble Beach County, Dick Crispo and Susan Klusmire of the Carmel Art Association, Tim Thomas of the Monterey History and Art Association, and Carol and John O'Neil, all of whom gave us support.

A heartfelt thank you goes to Harold Short, who scanned almost 200 photographs. He was as excited about the project as the authors, and he provided technical, artistic, and editorial advice. Stefan Hudson was always available for computer assistance. He and Harold patiently taught us the necessary scanning techniques.

Finally, we want to express gratitude to our husbands, John Hudson and Glynn Wood, who read drafts and were patient while the work was proceeding.

INTRODUCTION

Faces of the past—seen through photographs of Point Lobos—inspire both historian and general observer alike. Some stiffly gaze at a camera for studio portraits; others smile and laugh for a simple snapshot at a Sunday picnic. Through their faces, we can somehow touch them, know them, and begin to understand their lives. It is also fascinating to peer at a landscape of long ago, to see what the land looked like more than a century before, the way the mountains sloped before the trees grew in, and the men who built the roads that allowed access to a formerly wild area such as Point Lobos.

Many of the people who have lived at Point Lobos were there long before the invention of the camera. We will never know how the Native Americans who called this headland home looked. Rumsien Indians inhabited Point Lobos for 2,500 years, disappearing from the area before 1850. We can see middens of abalone shells they left behind and fire-darkened soil as we walk around Point Lobos. But we cannot see their real faces; they remain in the shadows. We can only pay them respect for their husbandry of the land. Similarly, no images remain of the Spanish *vaqueros*, or cowboys, sent by the Carmel Mission to Point Lobos to herd cattle in the 1770s. Spain lost control of Alta California in 1822 to Mexico, but the custom of issuing grants of free land to its citizens continued. There is no picture of Don Jose Escobar, the first grantee of Rancho San Jose y Chiquito, which included Point Lobos. The faces of subsequent owners, such as the Monterey Presidio soldiers who won the rancho in a card game, are also missing from the Point Lobos photographic record. Around 1851, several Chinese families established the first fishing village at Point Lobos' Whalers Cove. They left us a building, one of several houses and shacks that comprised their village, along with shards of pottery and other household artifacts. We have an image of just one of these people, Quock Mui, who was born in that small Chinese community.

The photographic history of Point Lobos begins with Portuguese whalers who had their houses in the meadow at the head of Whalers Cove. They arrived in 1861 and braved the sea around Point Lobos to hunt whales. With the introduction of kerosene, there was no further need for whale oil, so these whalers took to raising cattle and producing milk and cheese. Japanese abalone fishermen began to arrive at Whalers Cove at the end of the 19th century. They built their village on the bluff on the north side of the cove and pursued the abalone with great success, their efforts documented by a wealth of wonderful photographs. A business relationship grew between Gennosuke Kodani, a marine biologist sent by the Japanese government to the Monterey area to look for abalone fishing sites, and A.M. Allan, who bought the Point Lobos property in 1898. Kodani and Allan set up and operated an abalone cannery into the late 1920s.

The Allan family features prominently in this book. It was Allan who bought the land that became Point Lobos. There he made his family's home and developed enterprises such as abalone canning, ranching, and dairy farming, as well as sand and gravel mining. It was he who in 1899 set up a tollgate at the entrance of the property and charged visitors to enter Point Lobos to enjoy its beauty. Many members of the Allan and Kodani families still live in the area and have supplied family photographs that give us a vivid sense of what life was like on the

7

ranch at the beginning of the 20th century. Gennosuke and Fuku Kodani had nine children and lived close to the Allans. The families were very friendly; in an old photograph of the area, a footpath is clearly visible between the two houses, as children went back and forth to play. People came from all over the world to spend time at Point Lobos. Weddings, picnics, private celebrations, and even movie-making all took place here. Artists and photographers were awed by the majesty of the scenery. Poets and writers spoke of its splendor.

The land remains much as it was. Sea lions, harbor seals, and sea otters still delight in the waters of the coastline. The gray whales ply the coast twice a year on their migration between Alaska and Baja California; however, this book is about the people who lived at Point Lobos. They made their living in these magnificent surroundings and used the land and sea to survive. Today, only traces of their efforts remain, but their way of life partially survives in the photographic record. This book is also about those who have come to Point Lobos to find beauty, inspiration, and peace or simply came for the joy of looking at the land and sea. All these people let us see them through the eye of the camera.

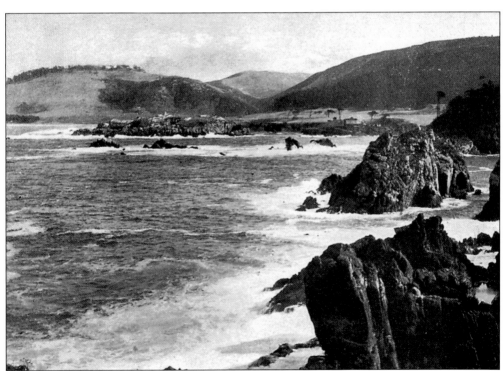

This postcard shows the coast of Point Lobos. The postage required for the United States and its possessions, Canada, and Mexico is 1¢, placing the postcard before 1951. (Jeff Haferman collection.)

One

WHALES AND ABALONE

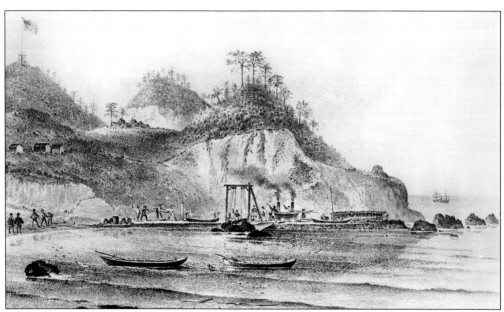

This etching is our earliest view of Point Lobos, credited to Charles Melville Scammon, a sea captain who observed the whaling operation at Point Lobos in 1865. Portuguese whalers started hunting whales here in 1861. To harpoon the whales, they rowed out to the open sea in long boats, shown here in the foreground. A whale is on the ramp by the dock and smoke is rising from the blubber pots. On Whalers Knoll (which was the lookout point) and signal hill, the American flag is flying. (Etching by Charles Melville Scammon, courtesy of Harrison Memorial Library.)

Manuel Silva came from the Azores. After arriving at Point Lobos, he began work on a typical six-man boat crew hunting whales. Later, he became captain of the Carmelo Bay Whaling Company, which operated between 1861 and 1882. Silva's daughter Flora Woods became the prototype for Dora Flood, the flamboyant but much beloved and admired madam in John Steinbeck's *Cannery Row*. This photo dates *c.* 1880. (Harrison Memorial Library.)

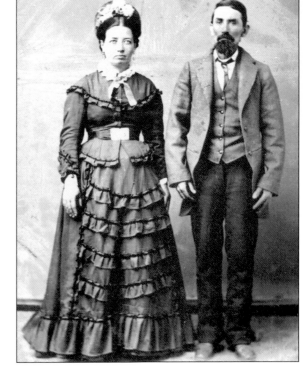

Christiano Machado and his wife, Maria, lived and worked in the Portuguese whaling settlement at Point Lobos when this picture was taken in 1868. Many young boys left the Azores to escape both poverty and the Portuguese draft, stowing away on American whaling ships or hiring on as sailors to make their way to America. Later in life, Christiano was hired as a caretaker by Father Casanova at the Carmel Mission. (Harrison Memorial Library.)

In 1874, Brothers Jose Francisco and Antonio de Silviera arrived at Point Lobos, where they found work hunting whales for the Carmelo Bay Whaling Company. (Harrison Memorial Library.)

Manuel Freitas joined the Carmelo Bay Whaling Company at Point Lobos in the 1870s. Eventually, kerosene replaced whale oil for lighting and made whaling unprofitable. As a result, many whalers took to other less dangerous occupations, such as dairy farming. (Harrison Memorial Library.)

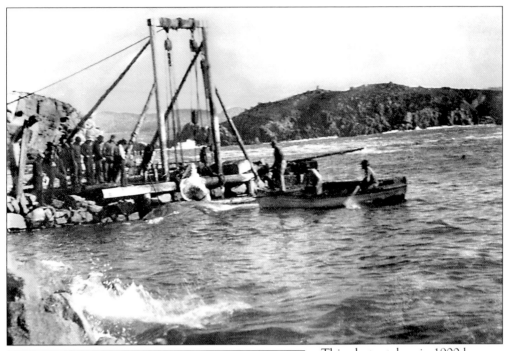

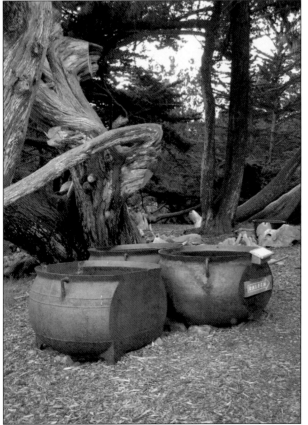

This photo, taken in 1900 by the new owner of Point Lobos, Alexander MacMillan Allan, may show the last whale taken from the sea around Point Lobos. After a whale was killed, two long boats towed it into Whalers Cove to be processed. The hoist on the dock was equipped with two large blocks and tackles to assist in cutting, or flensing, the blubber from the carcass. (Allan family collection.)

Large chunks of whale skin and blubber were dumped into these cast iron whale blubber pots, or try pots, to be rendered into oil. The fire under them was often refueled by the oil-soaked whale skin, which was scooped from the hot oil as it floated to the top. The pots in this photo were brought to Whalers Cove as part of the whaling exhibit. (Photo by Monica Hudson.)

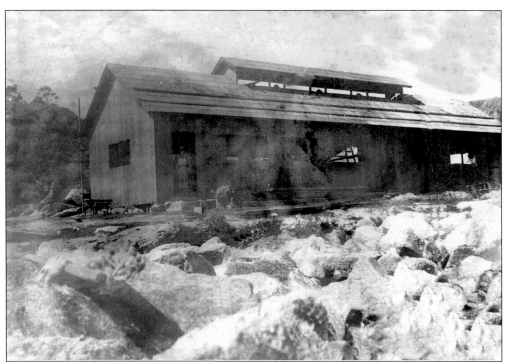

Abalone was abundant at Point Lobos and by 1902, A.M. Allan and his partner, Gennosuke Kodani, were building an abalone cannery at Whalers Cove. It was located next to the whaling station structure on the level ground in front of the granite quarry. Here the cannery is under construction. (Kodani family collection.)

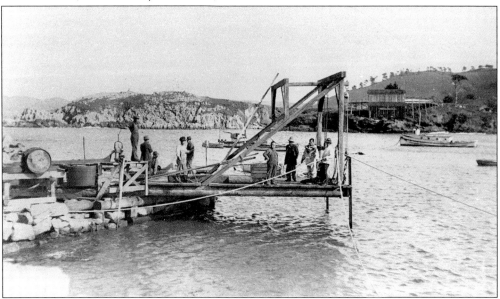

This 1903 side view of the loading dock and hoist at Whalers Cove shows the stone foundations that were built from rock left over from the quarry operation. The abalone cannery's first "mother ship," the *Lackawanna*, and a raft of smaller boats are anchored in the bay. The chute, used for loading coal and sand, is visible across the cove. (Kodani family collection.)

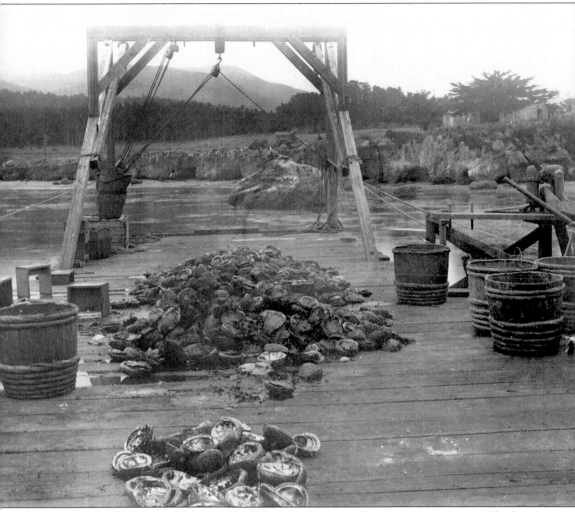

A sturdy loading dock and hoist were constructed to serve the canning enterprise. The heavy catches of abalone were hauled up with the help of block and tackle and dumped on the dock where the mollusks were then separated from their shells. Japanese bamboo buckets served to hold the abalone meat while it was washed with salt water pumped from the bay by the water pump on the right. In the distance, several Chinese-built cabins are visible, as well as one house of a planned residential development to be known as Carmelito. This photo dates from 1902. (Allan family collection.)

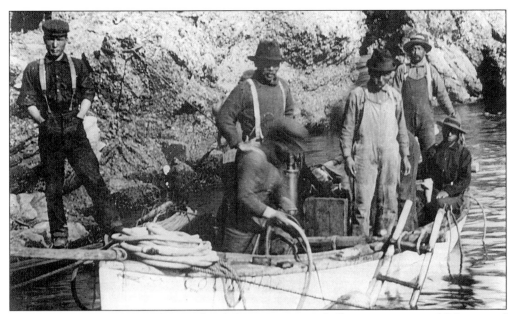

Once the canning operation began, the abalone growing in shallow water was quickly harvested and deep-water diving became a necessity. Mr. Kodani brought experienced hard-hat divers to Point Lobos from Japan. In this c. 1901 photo, the dive boat is anchored close to the shore, and the diver is descending a ladder fastened to the boat. An air hose is attached to his helmet and is controlled by the man in the boat. (Monterey Public Library.)

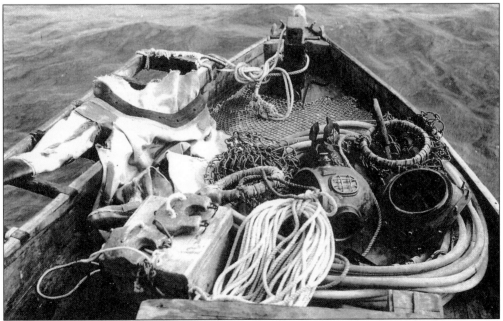

In the bow of this boat most of the diving gear is laid out. The cold water made it necessary to use a rubber suit. Divers wore wool underwear beneath their suits. The rest of the equipment consisted of a brass helmet and shoulder plate, lead weights for front and back, 16-pound shoes, an abalone string basket, $5/8$-inch manila lifeline, and 150 feet of air hose. (Ray Hattori collection.)

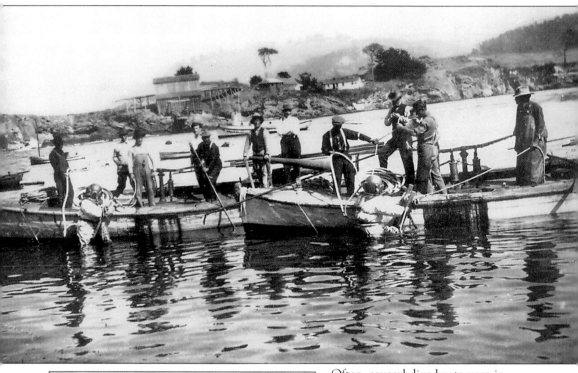

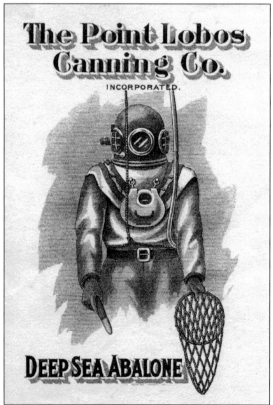

Often, several dive boats were in action simultaneously, as in this 1904 photo. The partners, Mr. Allan and Mr. Kodani, are observing the operation; Kodani is fourth, and Allan is third from the right. Each boat had its own hand-operated air pump mounted amidships to supply its diver with fresh air. Depending on the depth, pumping air was very tiring and the men assigned to pump took turns at regular intervals. In the background are the coal chute and the Japanese village. (Allan family collection.)

The Point Lobos Canning Company had its own logo for company letterheads and envelopes. This envelope graphic shows a hard-hat diver in helmet and suit, wearing a dive weight on his chest and holding an abalone pry and collecting basket. (Kodani family collection.)

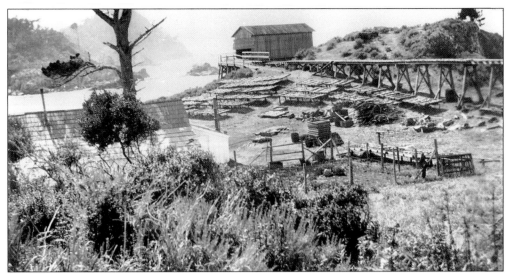

This 1903 photo was taken from a point close to the houses built for the Japanese abalone fishermen. Abalone drying racks cover the slope below the railroad track to the coal chute. Drying abalone took about six months. They were repeatedly soaked in brine and then dried on the racks. (Monterey Public Library.)

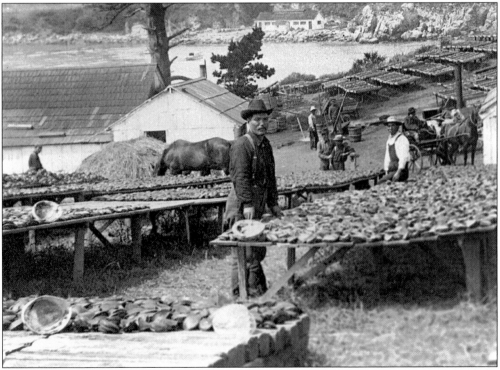

The drying racks in this photo are full of abalone meat carefully laid out. Some abalone shells were placed on the racks especially for this picture, taken in 1903. Mr. Kodani stands in the foreground with workers taking a break while watching the photographer. A large stack of hay is fodder for the workhorses. In the background are the earliest buildings of the Point Lobos Cannery. (Kodani family collection.)

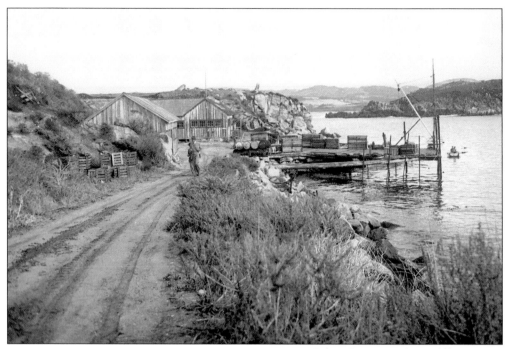

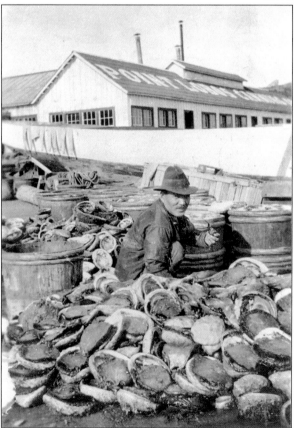

Julian Burnette, A.M. Allan's son-in-law, ran much of the cannery business in 1926, when this photo was taken. He and a Japanese worker walk up from the cannery, seemingly inspecting the stacks of "live boxes" along the road. These crates served as floating cages and were used to keep the abalone alive. More of them are stored on the pier along with a number of fuel barrels. (Allan family collection.)

Mr. Kodani poses for this 1922 photo amid a large abalone catch—shells with flesh still attached—in front of the cannery. The long white hull of the boat, the *Ida S.*, waits for restoration. The boat had been partially burned after it was confiscated from smugglers suspected of bringing Chinese into Monterey Bay. Allan purchased her in 1916 to add to his fleet of boats, but she remained a project unfinished. (Kodani family collection.)

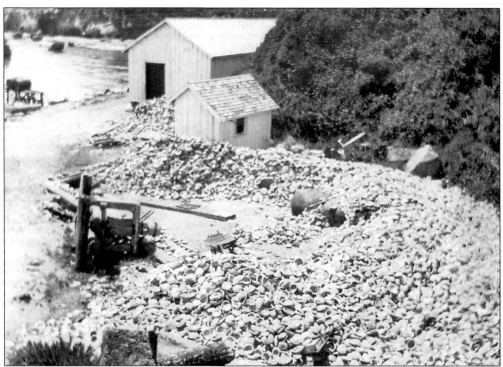

Over time, mountains of abalone shells accumulated alongside the cannery. There was a ready market for mother of pearl and much of it was exported. In Asia, it was popular as inlay for furniture, and in Europe, the shell was sought after for button manufacture. On the Monterey Peninsula, the shells became a popular tourist souvenir and were also used locally as garden ornaments. (Allan family collection.)

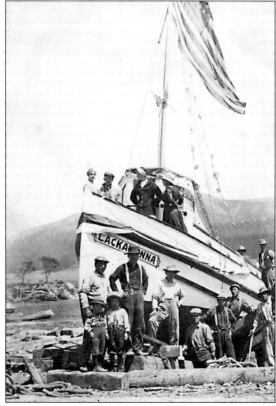

A.M. Allan acquired his first dive support boat in 1902 and named her the *Lackawanna*, after a river in his native Pennsylvania. Here the Lackawanna is relaunched in 1916 after an extensive overhaul. Friends and family gather around the boat on this happy occasion. (Allan family collection.)

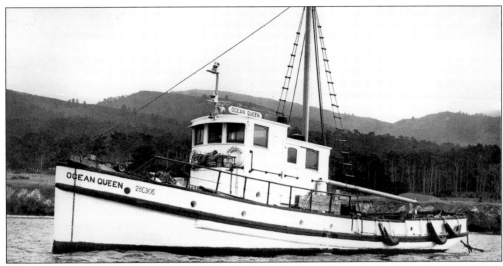

The *Ocean Queen* is at anchor in Whalers Cove. A fast, Canadian-built boat, she was 65 feet long and had a 45-horsepower engine. Before coming to Point Lobos, she had had an active career as a rumrunner and had been pursued by federal agents since 1919. In November of 1924, she was seized during a raid at Whalers Cove. A.M. Allan purchased her at auction in San Francisco and brought her back to Point Lobos to assist with his canning operations. (Allan family collection.)

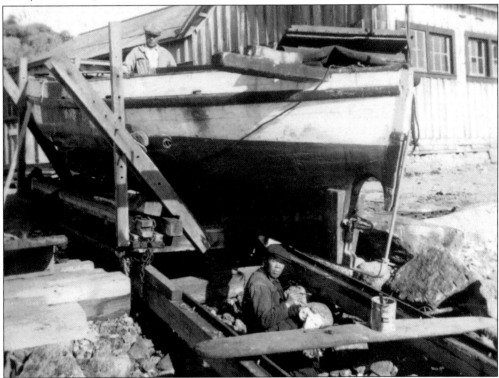

The fleet of dive boats needed regular maintenance, and a marine railway was located in front of the cannery to pull the boats out of the water. This boat is chained to the cradle that was pulled out of the water along the slipway. (Kodani family collection.)

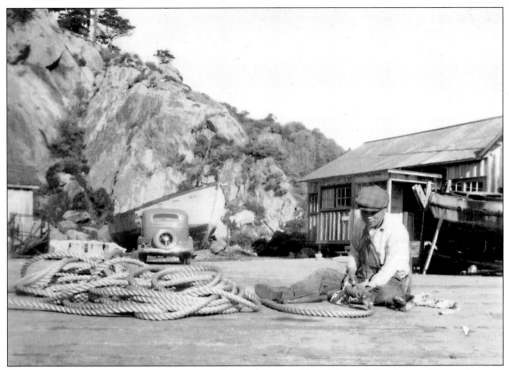

Equipment maintenance was constantly underway. Here diver Hayakawa is serving, or wrapping, the end of a manila line so it would not unravel. He is seated on the ground in front of the cannery and the *Ida S.* is sitting high and dry in the parking area, still waiting to be refurbished. This photo is from the early 1930s. (Kodani family collection.)

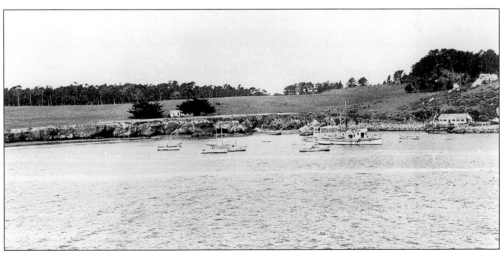

This photo was taken from a boat heading into Whalers Cove. Directly ahead is the fleet of dive boats anchored along with the mother ship, *Lackawanna*. This virtually treeless scene from 1933 contrasts with the present landscape where this part of the cove is thickly covered in forest. (Kodani family collection.)

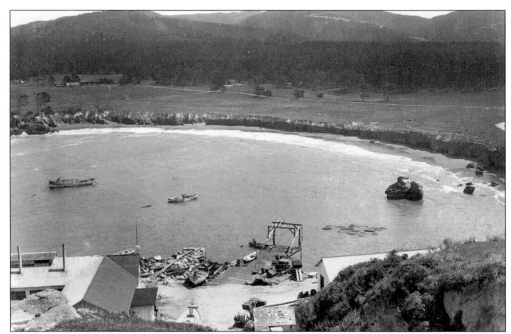

This photo was taken in 1916 from above the quarry, overlooking the cannery and Whalers Cove. The Allans' Big House and barn are at the upper left. Bassett Avenue runs horizontally out to Cypress Grove. Anchored in the cove are the *Lackawanna*, a dive boat, and in the right foreground a number of floating "live boxes" full of abalone. (Photo by Lewis Josselyn, courtesy of the Pat Hathaway collection.)

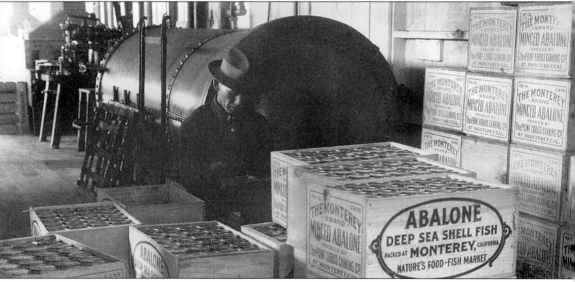

Inside the Point Lobos Cannery wooden boxes are stacked full of minced, canned abalone, ready for shipping. The boxes refer to the Monterey brand, packed at Monterey by the Point Lobos Canning Company. Since Monterey was the closest post office, it was used in the address. After the Whalers Cove operation closed down in 1928, canning abalone continued at Allan's Monterey and Cayucos canneries. This photo was taken by Lewis Josselyn in 1916. (Pat Hathaway collection.)

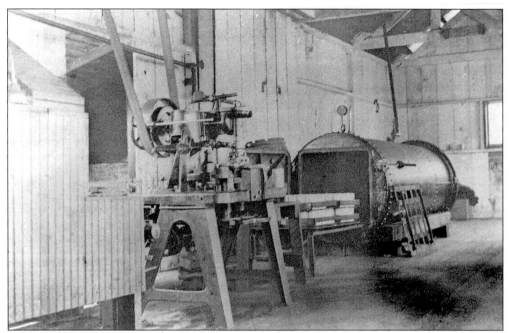

The cannery was in full operation when this photo was taken in 1916. On the right is the large steam-heated retort. An empty rack leans up against it, waiting to be filled with abalone cans to be cooked. Racks full of cans are in front of the retort, ready to be either cooked or sealed. On the machine next to it, cans are in the process of being sealed. This machine is driven by an overhead belt powered by a line shaft. (Allan family collection.)

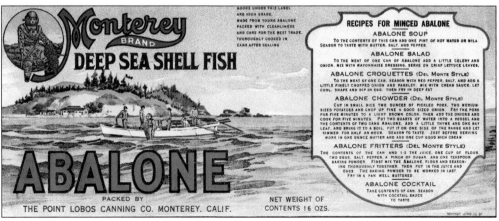

This label was used on cans leaving the Point Lobos Cannery. It is an artistic rendering of Japanese abalone divers in a boat, a view of the cannery with a backdrop of the granite quarry, Whalers Knoll, and Big Dome. The recipe on the label is from the kitchen of A.M. Allan's wife, Satie, who experimented with preparing abalone every imaginable way. (Allan family collection.)

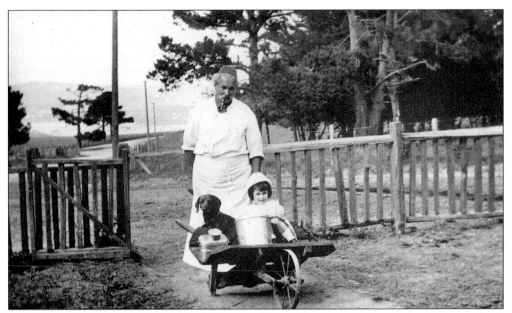

Pop Ernest Doelter, complete with red fez, was a famous character at Point Lobos. He is credited with inventing the abalone steak. The abalone from Whalers Cove had been dried or canned and sent to the Far East. Pop Ernest pounded, breaded, and fried it. His was the first restaurant on Fisherman's Wharf, and an abalone sandwich could be had for 15¢. He lived at Point Lobos when this picture was taken in 1915. In this photo, Pop is pushing his little friends in a wheelbarrow. (Harrison Memorial Library.)

Pop Ernest's son, Karl, is standing outside the Whalers Cabin in 1918 wearing puttees, or leggings, which he had worn during his World War I service. Karl helped his father and when Pop died, he took over the restaurant. Pop and Karl used the Whalers Cabin (shown here with a new coat of whitewash) to process abalone for the restaurant. (Allan family collection.)

Two

WORKING THE LAND

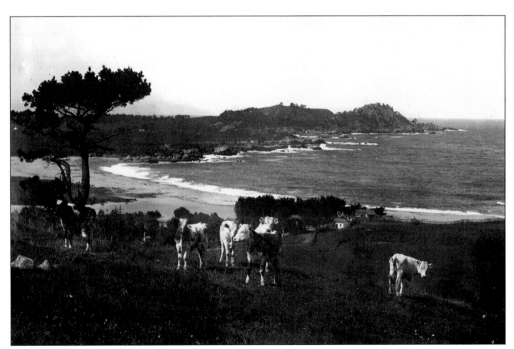

In the early days, keeping a cow for milk was quite common along this lonely coast, where self-reliance was necessary and prized; however, by the 1880s, some of the whaling families had started dairies to make a living. Several dairies operated at and around Point Lobos. This c.1883 photo shows the cattle and homestead of Antonio Victorine at the mouth of the San Jose Creek, the northern border of Point Lobos. (Allan family collection.)

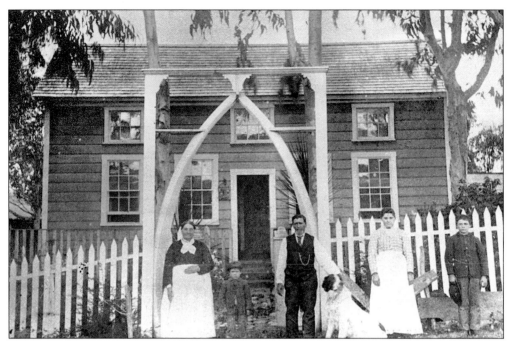

The old Victorine family home, built in 1875, still stands in a eucalyptus grove behind Bay School. In front of their home, under an arch made from whale bone, are Antonio and Isabel Maria Victorine with family members. This photo dates from 1888. (Harrison Memorial Library.)

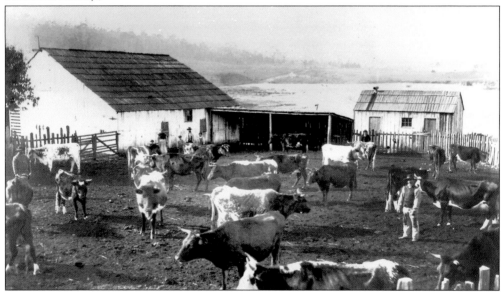

The Victorine barn, shed and outbuilding are directly above the beach, acting as a windbreak for the animals and people in the corral. The corral fence is made of split redwood pickets, which makes it a very strong and durable enclosure. The family is in the yard in this 1884 photo. Note the man in the foreground on the right is wearing the low-brimmed hat and clothing reminiscent of the *vaquero*, or cowboy, of California's Spanish and Mexican periods (1769–1846). (Harrison Memorial Library.)

Antonio and Maria Victorine pose for a traditional photograph. Antonio, a Portuguese whaler, had come from the Azores. He was in charge of the Carmelo Bay Whaling Company for a period of time. Maria helped run the dairy operation. (Harrison Memorial Library.)

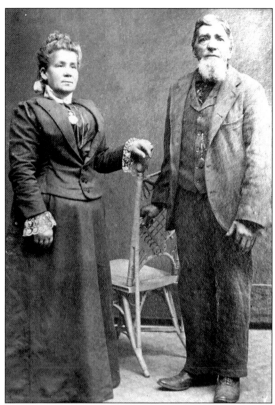

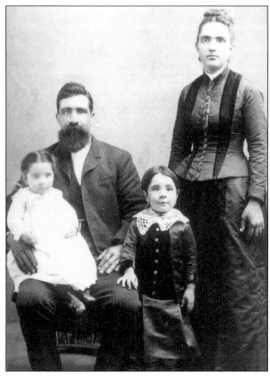

Antonio and Maria Brazil with their two daughters, Mary and Isabel, are pictured here around 1887. The two little girls were born at Point Lobos in the 1880s. (Harrison Memorial Library.)

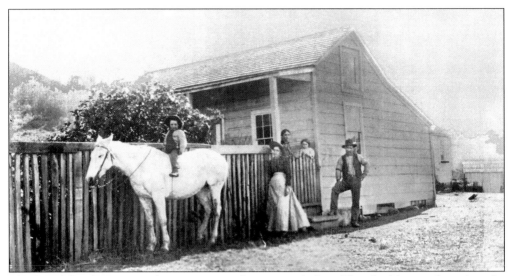

The Brazil family came to the coast as ranchers, not whalers. They had begun their dairy by 1890 at the location where the Carmelite Monastery stands today, along the San Jose Creek. Children learned to ride very young, as this little boy on the white horse confirms. He and his family are in front of the Brazil homestead. This photo was taken *c.* 1891. (Harrison Memorial Library.)

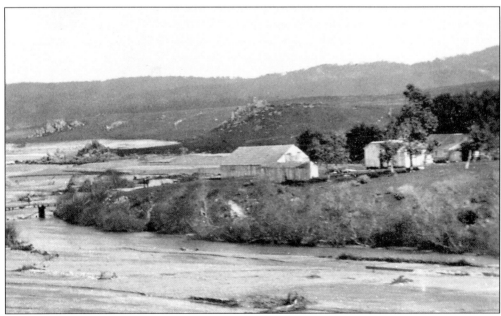

The homestead and dairy barns of the Brazil family are high above the floodwaters in this 1911 photo. The San Jose Creek rose above its banks and washed out the bridge along the present-day right-of-way of Highway 1. (Allan family collection.)

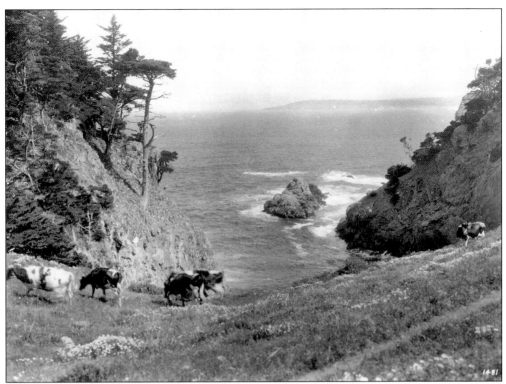

Cattle, first raised for hides and tallow and later for beef, had grazed Point Lobos for over 100 years when this photo was taken in 1929. These Holstein dairy cows from the Point Lobos Dairy are grazing at Cypress Cove. (Photo by Louis S. Slevin, courtesy of the Bancroft Library, University of California, Berkeley.)

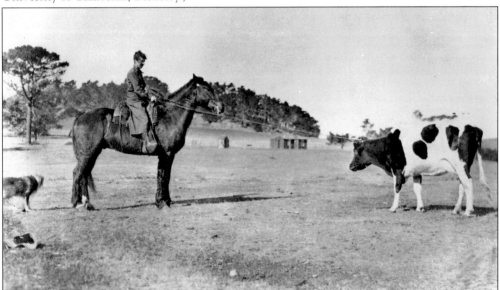

In the early 1920s, A.M. Allan bought a few cows at the San Francisco Exposition. His daughter, Eunice, showed great interest and skill with the livestock and proved an invaluable help to him. Here she is roping a Holstein cow from her horse, Duke. (Allan family collection.)

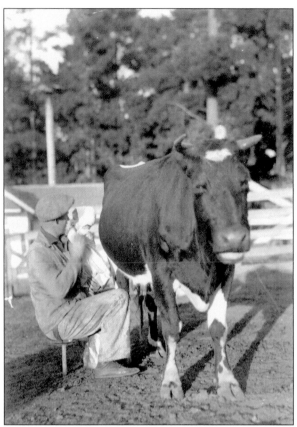

Tom Riley was hired to help with the dairy. Here, in 1922, he sits on his one-legged milker's stool holding A.M. Allan's first grandchild, little Helen Burnette, while the patient Holstein is waiting to be milked. That year, Tom became a member of the family when he married Allan's daughter, Eunice. (Allan family collection.)

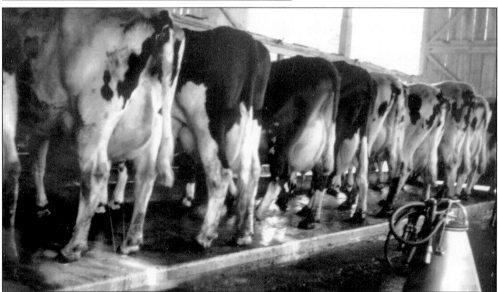

In this photo from the late 1940s, the Holsteins are being milked by machine. Eunice and Tom Riley constantly modernized the Point Lobos Dairy operation to keep up with changing laws and regulations. Small, family dairies eventually became unprofitable and in 1950, the Point Lobos Dairy closed. (Allan family collection.)

Snorts the horse looks as if he owns the place in this 1924 photo. He was Tom Riley's riding horse and is standing in front of the landmark barn that A.M. Allan built in 1903 next to the Big House. (Allan family collection.)

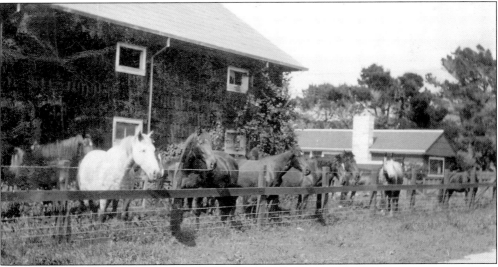

This remuda, or group of saddle horses, was kept close to the barn so transportation would be easily available. These horses were very versatile and were used for riding after cattle, going to school, or simply for pleasure. For a trip into town, they were trained to pull a buggy or, if it came to hauling hay and supplies, a wagon. Lady Luck, the white horse in this *c.* 1920 photo, was a favorite. (Allan family collection.)

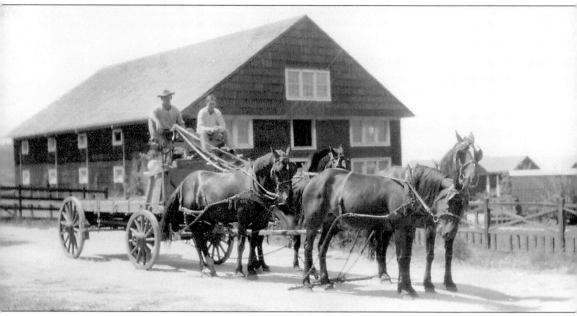

A four-horse team and wagon are ready to leave the barn area for a load of hay. Tom Riley has the reins and his brother, Charlie, is seated next to him. In 1929, Charlie came out west from upstate New York to help out and spend a couple of months. Point Lobos must have cast a spell, for he spent two years instead. Besides the hay, there was room for a workshop, office, tack room, and darkroom in the large barn. The box stalls shared space with the farming equipment and vehicles. The loft was ideal storage for anything and everything. (Allan family collection.)

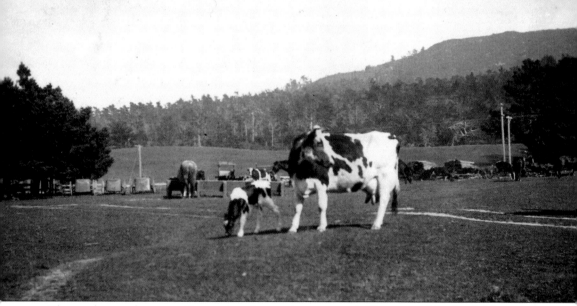

The cattle were kept outside, grazing the ranch year round. They stayed in the field near the house and barn when they were ready to have their calves. This Holstein cow with her young is part of the Point Lobos dairy herd. To the right in the background, timbers are stacked—part of an Allan construction project. Michael's Hill is in the distance. (Allan family collection.)

In this early 1920s photo, loose hay is loaded into the barn. It is lifted up to the hayloft with the help of a hoist that was powered by a gasoline engine. (Allan family collection.)

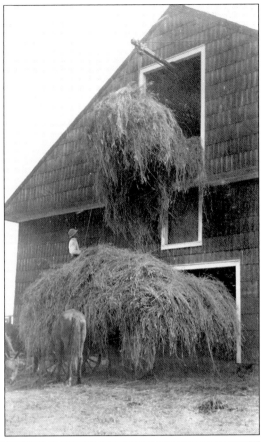

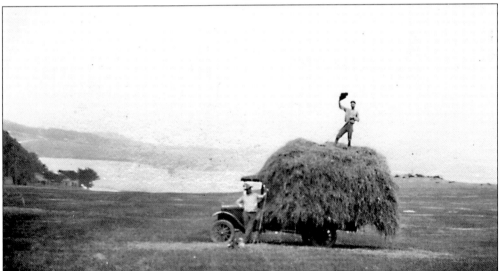

George Kodani liked to help around the ranch. In this photo, taken in 1929, he and Tom Riley collect hay just north of the San Jose Creek. Today, the Carmel Meadows subdivision overlooks that land. Note the Victorine family homestead buildings and the road to Point Lobos in the background. (Kodani family collection.)

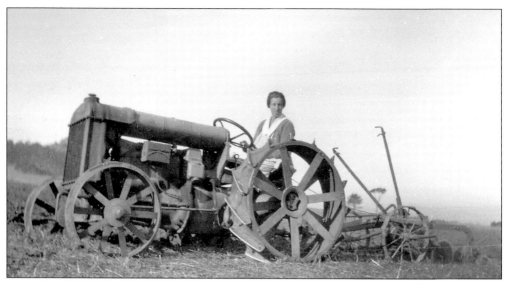

In 1923, Eunice was pregnant with her first child; however, the cows still had to be milked and the barley had to be planted. Here she is driving the tractor pulling the disc harrow before planting. (Allan family collection.)

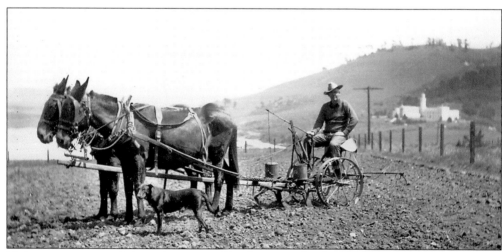

Various crops were tried on this piece of land just south of the San Jose Creek. For several years during the early 1930s it was leased to Batista "Bob" Odello, who grew artichokes here. Barley for the horses was another crop grown. Tom Riley is sitting on the seeder pulled by two mules, accompanied by his dog. Note the Carmelite Monastery in the background. (Allan family collection.)

Three

SAND, ROCKS, AND COAL

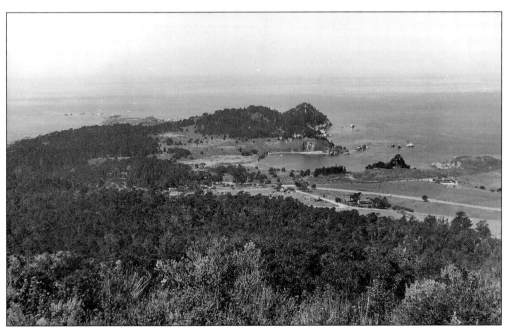

Point Lobos appears totally pristine today, protected by its status as a state reserve; however, by 1854, the first industrial activity is recorded. Joseph S. Emery and his partner, Abner Bassett, established a granite quarry at Whalers Cove. They employed 35 men, most of whom were believed to be Chinese. The granite slabs were shipped to Monterey and San Francisco, where they were used in construction. In this 1954 photo, the scar is still clearly visible 100 years later. (Allan family collection.)

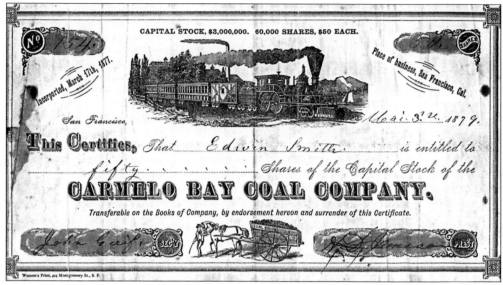

In March of 1877, Emery and Bassett incorporated the Carmelo Bay Coal Company and were issuing stock. Edwin Smith, holder of this certificate, had acquired fifty shares in the company in 1879. By 1898, A.M. Allan, an experienced miner and contractor, had become involved in the coal mine at Mal Paso Canyon. (Allan family collection.)

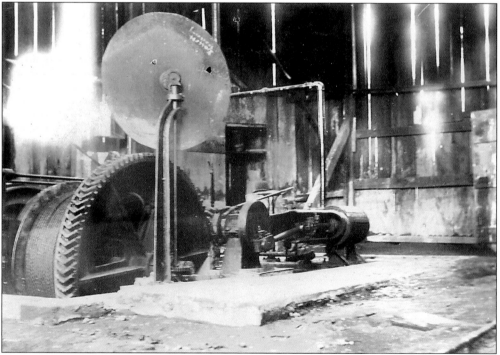

The coal mine was located south of Point Lobos in the Mal Paso Canyon. This photo was taken inside the building, which sheltered the hoisting equipment for the mine. The mine elevator car, or skip, was lowered down the shaft on a cable. Visible here is the drum on which that cable was wound. The large disc on the upright support served as the skip depth indicator. To the right is the steam engine that powered the equipment. (Allan family collection.)

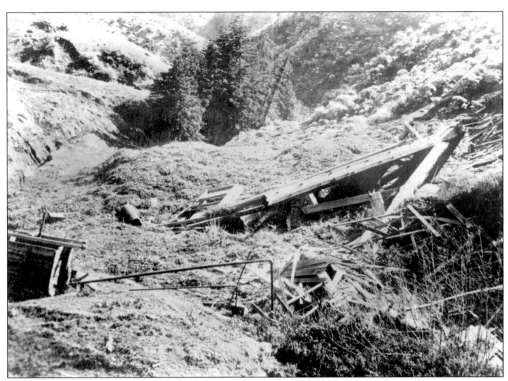

The coal, lignite, was of poor quality and the operation was barely profitable. By 1898, a large surface slide had closed down the mining operation. In this 1919 photo, the redwood timbers of the hoist tower are on the ground, partly covered by the slide. (Photo by Louis S. Slevin, courtesy of Harrison Memorial Library.)

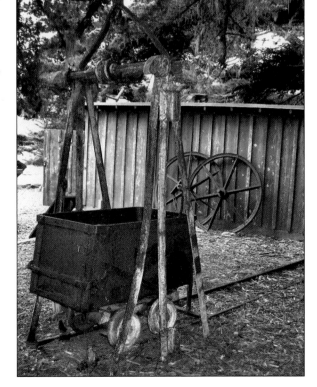

The mine skip and hoist pulleys, or large wheels, were salvaged from the coal mine almost 100 years after the slide by John Hudson, with help from Point Lobos Reserve staff. Today, they are part of an exhibit behind the Whalers Cabin Museum. (Photo by Monica Hudson.)

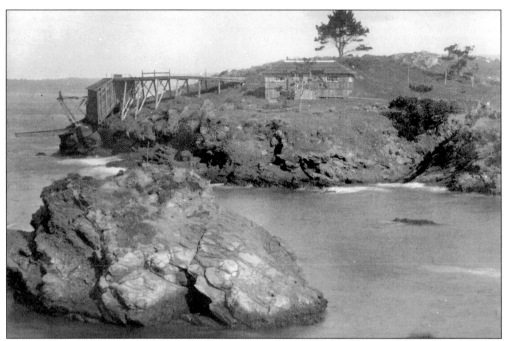

Getting the coal to market proved to be a challenge. Plans were made and the land surveyed to build a railroad to take it out of the Mal Paso Canyon, a project that never materialized. An attempt to haul the coal with a six-horse team over the ridge down Wildcat Canyon failed. In the end, the most reliable route proved to be the longest—over the top of Lobos Ridge and down to Whalers Cove. Here a coal chute was built to load the coal into coastal steamers that came close in below the bluff. (1909 photo by L. S. Slevin, courtesy of the Pat Hathaway collection.)

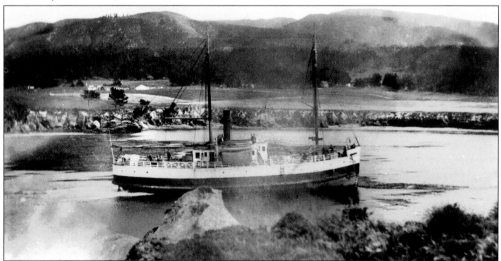

In the 19th century, trade on the rugged central coast of California was conducted by sea because no roads existed. With no wharves for the ships to dock, goods were transferred by such devices as overhead trams, booms, or chutes. *Gipsy* was such a steamer. Here, *c.* 1900, she is in Whalers Cove waiting to take on coal, sand, or any other goods that needed shipping. (Allan family collection.)

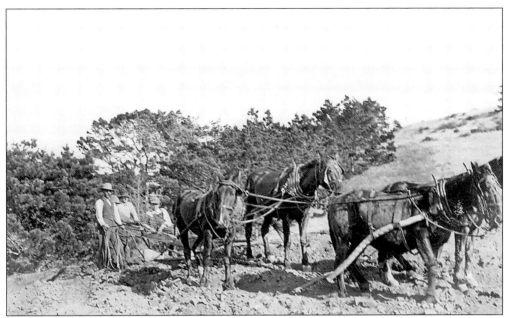

Road building and maintenance were crucial to any successful commercial enterprise: therefore, road and bridge construction was an ongoing project for A.M. Allan, both north and south of his Point Lobos property. A four-horse team was used in 1915 to grade the road going south to the Mal Paso Canyon. (Photo by A.M. Allan, courtesy of the Allan family collection.)

A horse and buggy are using the narrow, but well-maintained road coming from the Gibson Creek toward Point Lobos in this 1905 photograph. (Photo by Edgar A. Cohen, courtesy of the Allan family collection.)

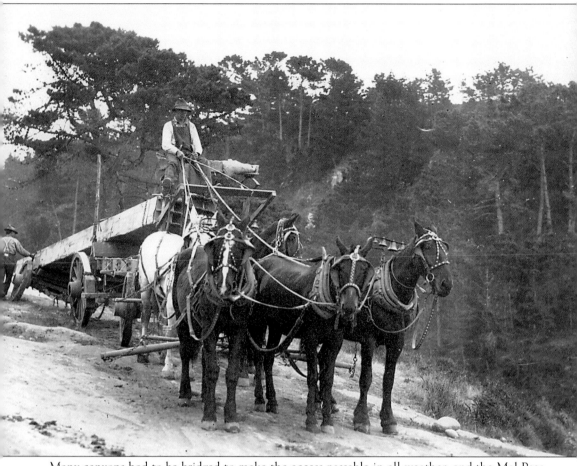

Many canyons had to be bridged to make the access passable in all weather, and the Mal Paso was a particular challenge. When a new bridge was built over the Pajaro River, Allan bought the old bridge and hauled the large timber to the site with a five-horse team. It looks as if they got a wheel in a rut as the axle and load are tilted. (Photo by A.M. Allan, courtesy of the Allan family collection.)

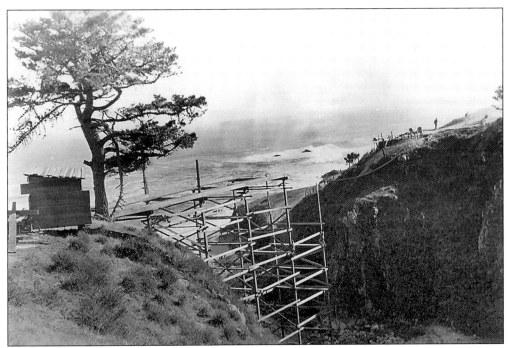

Prior to the construction of this bridge, the road led into the steep canyon, crossed the water upstream, and wound itself back out of the canyon. Here the falsework, or scaffolding, is being installed prior to the assembly of the bridge. (Photo by A.M. Allan, courtesy of the Allan family collection.)

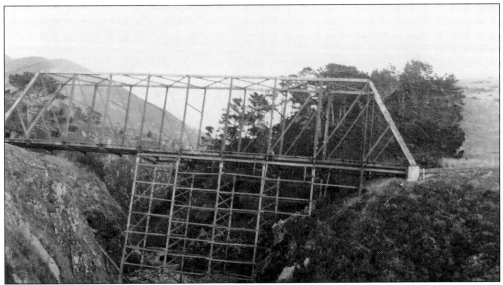

In 1915, the new bridge at Mal Paso Canyon was under construction. The supporting truss was installed above the road bed. Part of the false work, used in construction, still needs to be removed from below the bridge. Allan, who took this photo, kept a good photographic record of his many projects and developed his negatives in the darkroom in his barn. (Allan family collection.)

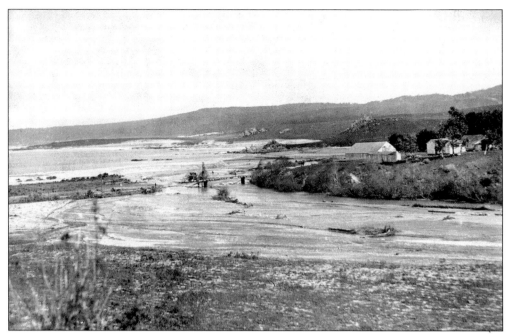

During the exceptionally wet winter of 1911, the San Jose Creek flooded and washed out the bridge where the creek enters Carmel Bay. Any trips to Monterey had to be delayed as the ranch was completely cut off. (Allan family collection.)

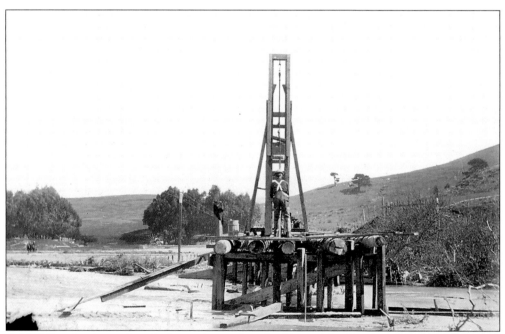

A.M. Allan checks on the pile driver during the rebuilding of the San Jose Creek Bridge, which washed out during the heavy flooding of 1911. Pilings were driven into the creek bed to support the road. The tower allowed the weight to be lifted high above the pile and then dropped down on it, hammering it into the ground. (Allan family collection.)

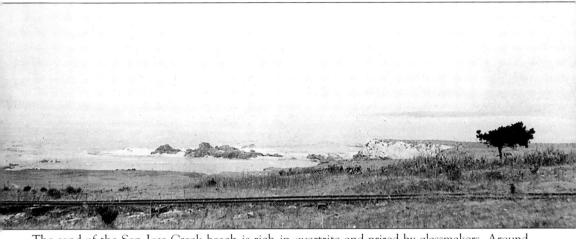

The sand of the San Jose Creek beach is rich in quartzite and prized by glassmakers. Around 1899, A.M. Allan mined and shipped sand from that beach to a glass manufacturer in Alameda. Track was laid from the beach to Whalers Cove so the sand could be shipped by sea. In this photo, the rails of the track are clearly visible. (Allan family collection.)

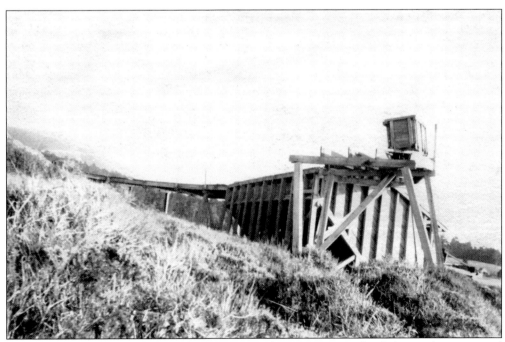

The old coal chute at Whalers Cove was pressed into service to load the sand into coastal schooners for transport to Alameda in the San Francisco Bay. In this 1924 photo, an ore car is on the track and the storage bunker is below the track to the left. (Kodani family collection.)

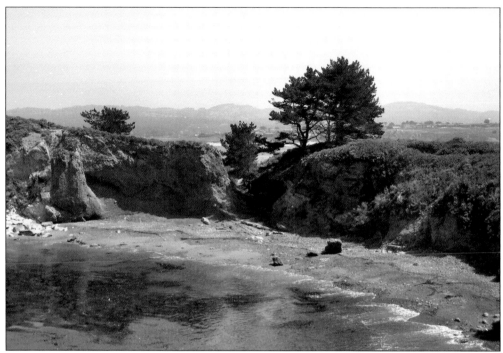

For a brief time in the mid-1920s, gravel was mined at Point Lobos. Contractor Sidney Ruthven of Monterey bought the gravel, which was ideal roofing material . He constructed a road from the Pit to the San Jose Creek, where the gravel was crushed and shipped by truck. The deep cut he made to gain access to the Pit is visible here. (Photo by Monica Hudson.)

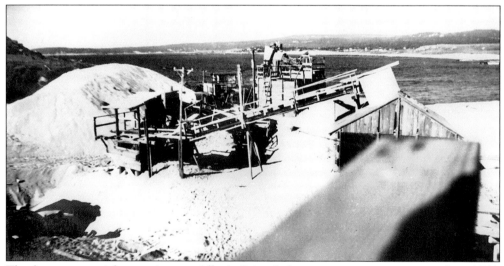

The last commercial operation on Allan's Point Lobos property came to an end in 1954, when the Monterey Sand Company closed the sand plant at San Jose Creek. During World War II, the uniquely hard and coarse sand was mined, graded, washed, dried, and sacked here, then used for sandblasting the bottom of ships. (McDonald family collection.)

Four

HOMES AT WHALERS COVE

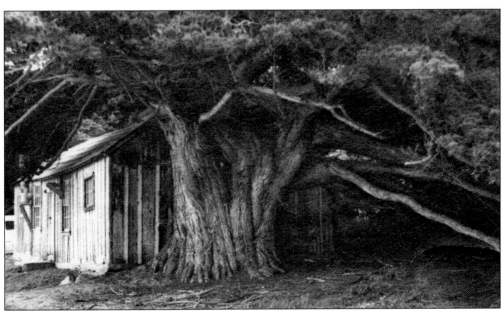

The first people to build permanent houses in the modern era were two Chinese fishing families who arrived from China in junks c. 1851. They had heard of the safe waters and rich fishing in Carmel Bay, and they made Whalers Cove and Stillwater Cove their bases. Their village at Point Lobos consisted of a few small houses and shacks. The house in this photo was the only one allowed to remain standing when the State of California created the Point Lobos State Reserve in 1933. It is called the Whalers Cabin and was photographed in 1960 by George A. Short. (Harold Short collection.)

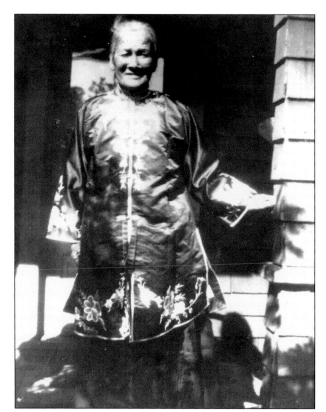

No pictures exist in the Point Lobos photographic record of the Chinese families who arrived in 1851. The first Chinese baby to be born at Point Lobos was Quock Mui in 1859; she was later also known as Spanish Mary because of her fluency in Spanish. Her family eventually moved to Monterey's Chinatown. Here she is later in life, photographed by Mary Chin Lee (her granddaughter) in front of her home near Cannery Row. (Harrison Memorial Library.)

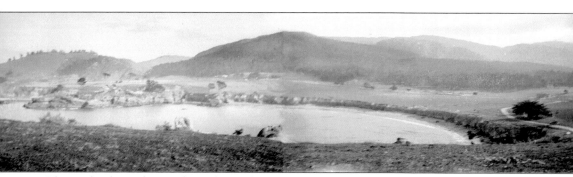

This early photo shows where the settlements at Point Lobos were located. This panoramic view shows how the Chinese fishermen built in the area of the Whalers Cabin at the right, the Portuguese whalers in the large meadow at the head of the cove, and the Japanese abalone divers on the rocky point near the coal chute at the far left. (Allan family collection.)

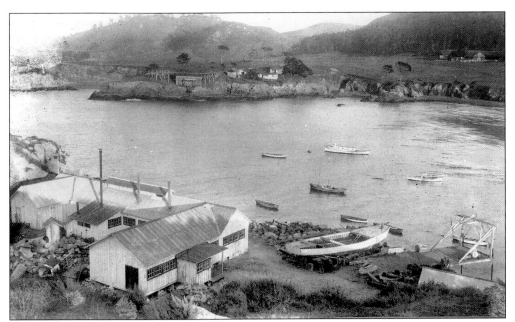

Overlooking Whalers Cove, the homes of the Japanese village are clearly visible across the water from the abalone cannery. In 1916 the village was still growing. Its nearest neighbor was the Allan family whose home and large barn are visible to the right. There was hardly a tree between the two settlements as it was kept clear by grazing cattle and horses. (Photo by Lewis Josselyn, courtesy of the Pat Hathaway collection.)

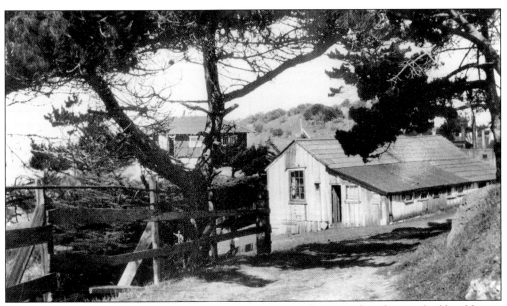

The first house encountered upon entering the Japanese village was the whitewashed bunkhouse built for the Japanese dive crew. Most of the divers came from Japan without families and stayed a few months or years before returning home. This photo was taken in 1930, shortly before the change to public ownership. Eventually, all the buildings were either moved or dismantled. Today, no trace remains of the village. (Kodani family collection.)

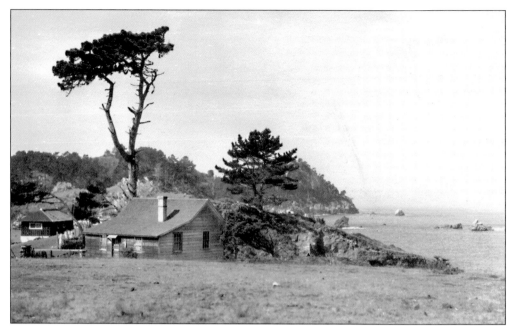

This charming house, the Owls Nest, seen in this 1922 photograph, was originally built along the road just above San Jose Creek. From there it was moved to the Pit in the Japanese village and in 1932 to its present location, on Riley Ranch Road. The old, characteristic lone Monterey pine tree was a landmark. (Kodani family collection.)

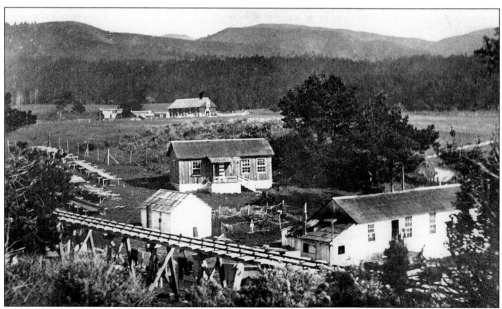

This 1908 view of the Japanese village shows the Kodani home in the center and the bunkhouse in right foreground. The fenced-in vegetable garden is strategically placed between the buildings to give it protection from livestock, deer, and the north wind. The coal chute trestle and abalone drying racks are on the left and in the background are the Allan ranch buildings. (Harrison Memorial Library.)

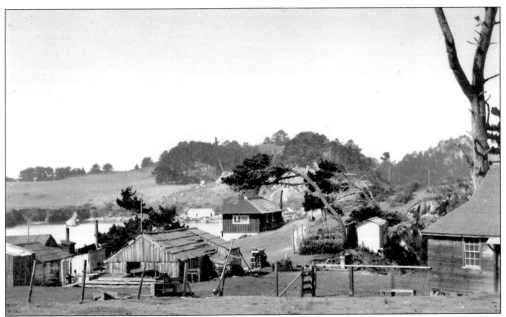

A bucolic village scene is shown here, complete with laundry on the line and neatly stacked wood piles. A lot of wood was used for cooking and heating water for the Japanese soaking tub, which was located next to the cookhouse. The Owls Nest is to the right and the guesthouse, bunkhouse, and large and small sheds are in the center. A.M. Allan's granddaughter, Mary Riley, has fond memories of playing with her friend, Satako, in the dining room of the bunkhouse. (Photo by K.B. Ninomiya, courtesy of the Kodani family collection.)

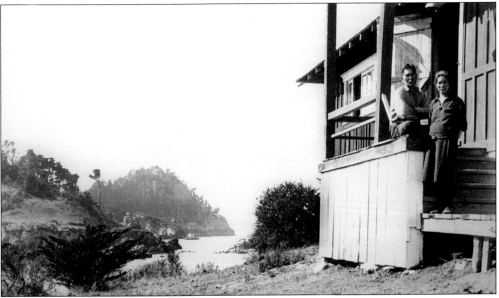

The small community often had guests and by 1926 it had become necessary to build lodging for them. Many a Japanese artist stayed here for weeks at a time to paint and enjoy the spectacular views of Point Lobos. Beautiful paintings covered the interior, gifts of visiting artists. Mr. and Mrs. Kodani are standing on the guesthouse porch. (Photo by K.B. Ninomiya, courtesy of the Kodani family collection)

This part of the Japanese village is situated above the Pit, here seen from Coal Chute Point. The whitewashed outhouse is poised over the cliff in this photograph, taken c. 1930. A.M. Allan's barn is visible in the distant background. (Kodani family collection, courtesy of Harrison Memorial Library.)

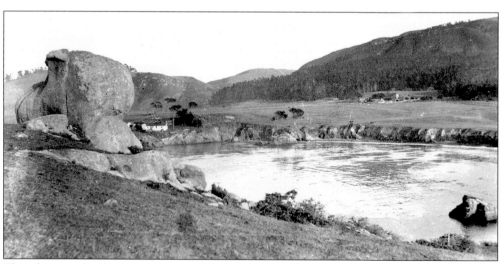

This photograph of Whalers Cove and its homes was taken c. 1920 and shows Granite Point, the Japanese village, and the A.M. Allan house and barn. Note the lack of vegetation. (Allan family collection.)

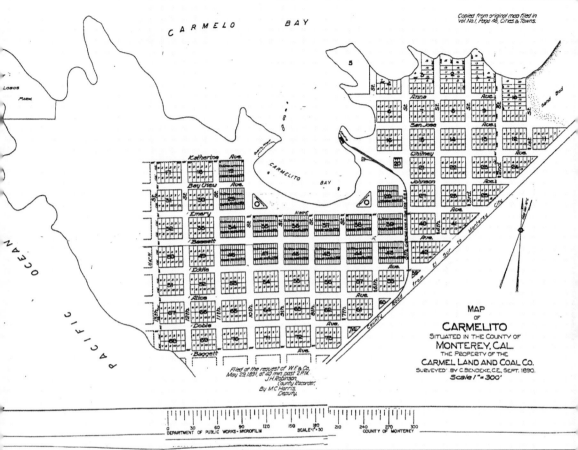

The Carmel Land and Coal Company, which received clear title to Point Lobos in 1888, had plans to build homes at Whalers Cove. This is the subdivision map for the small town of Carmelito, which was to be built around Whalers Cove, here identified as Carmelito Bay. Note along Fifth Street the right-of-way of the coal mine railroad. In 1898, A.M. Allan purchased Point Lobos and in the early 1900s he began to buy back parcels that had been sold. After years of negotiations, he was eventually able to have the subdivision removed from the county record. In this way, he ensured that no large-scale development would take place and Point Lobos would be preserved. (Allan family collection)

This is a fascinating view of the crossroads at Point Lobos c. 1922. The old highway ran to the east of the A.M. Allan home. At this point, it turned to the left toward the Carmel Highlands and Big Sur. The sign points straight to Point Lobos along Bassett Avenue, where a gate controlled access. (Photo by Lewis Josselyn, courtesy of the Pat Hathaway collection.)

This is Bassett Avenue, the main road in Point Lobos, looking west in 1909. The lots of the Carmelito subdivision are laid out on both sides of the avenue and stretch into the distance. The Whalers Cabin is on the right and Whalers Knoll is visible in the background. The open landscape was maintained by grazing cattle. (Harrison Memorial Library.)

This 1915 view of the Whalers Cove area was taken from what is today the parking lot. It includes one of the subdivision houses, the Morales house, in the background at center. The Allan ranch buildings are to the left. (Photo by Henry J. Durgin, courtesy of the Pat Hathaway collection.)

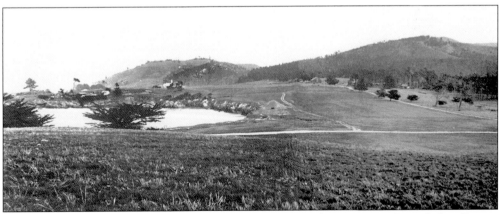

This 1934 wide view shows Whalers Cove and the main road coming into Point Lobos, Bassett Avenue, lined with a few trees. Two of the Carmelito homes are visible to the right of the avenue. The hill above them is Michael's Hill, and Fish's Hill is in the center. At its base is the newly built Carmelite Monastery. The Japanese village stands along the cove to the left. (Harrison Memorial Library.)

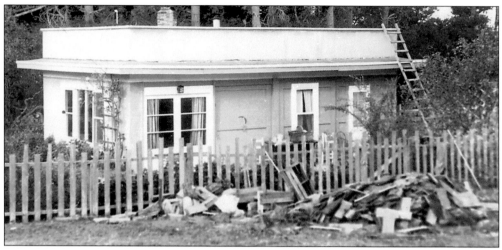

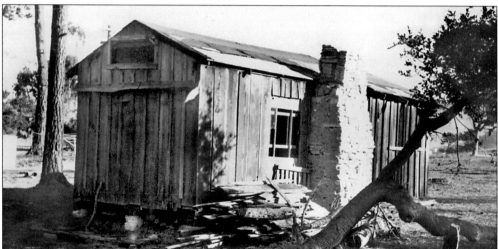

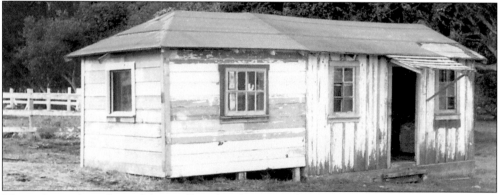

These photos show three of the small weekend cottages that had been built in the development known as Carmelito. A.M. Allan bought them back and used them for housing. Because they were located east of Highway 1, on Allan property, they were left standing after the State of California established the Point Lobos State Reserve in 1933. One of the structures, the Gould garage at top, survives to this day. (Allan family collection.)

Five

LIFE AT POINT LOBOS

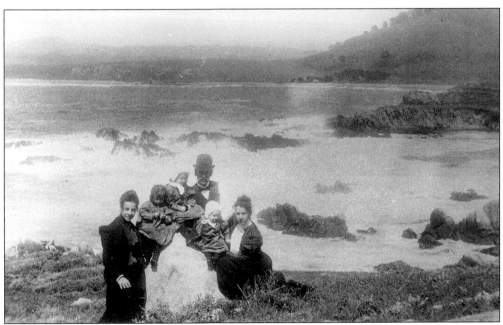

After A.M. Allan bought Point Lobos in 1898, he moved his wife and three small daughters from Oakland. In this early photo, the whole family is together along the shore at Moss Cove. In the background are Fish's Hill and the elevation where the Carmel Meadows subdivision stands today. From left to right are the following: longtime Allan family friend Erma Frank; daughters Helen and Eunice, perched on a rock with A.M. Allan on the side; and baby Margaret, held by her mother, Satie Morgan Allan. (Allan family collection.)

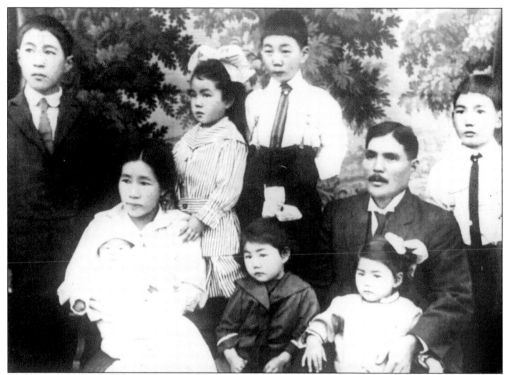

Gennosuke Kodani brought his wife, Fuku, and firstborn son, Hideo, from Japan to Point Lobos. This family photo was taken in 1917 with seven of their children pictured. The backdrop is a floral painted canvas that was unrolled to create this formal setting. From left to right are the following: (seated in front) mother Fuku, with one-year-old Yoshiko in her arms; Kuniko; and Takeko, sitting on her father, Gennosuke's, lap; (standing in back) Hideo, Fusako, Seizo, and George. Later, Gennosuke and Fuku had two more children, Satoko and Eugene. (Kodani family collection.)

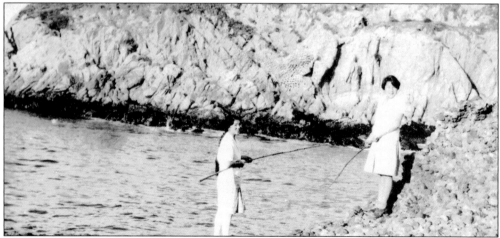

The children learned to fish at a young age. Usually, when extra dinner guests arrived, the girls took their poles and went fishing. They were adept at collecting mussels, sea urchins, and seaweed and would come back with a nice catch to augment the abalone feast. The village was quite self-sufficient, a necessity, for it was a long way into town. (Kodani family collection.)

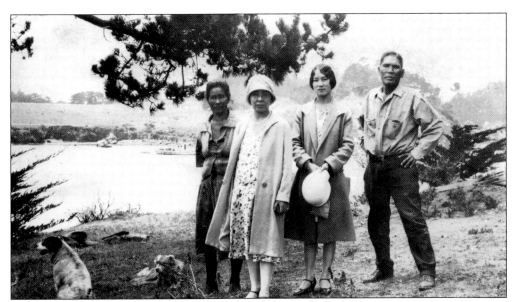

Many friends from Monterey flocked to Point Lobos to spend time with the Kodani family and to enjoy the beauty of the area. Here two well-dressed guests from town are flanked by Gennosuke and Fuku. On this hazy day, the Big Dome is barely visible in the distance behind them. Over the years, the Kodani family had a number of beloved dogs, which they named for the Apostles. Here Luke and Matthew are curled up alongside. (Kodani family collection.)

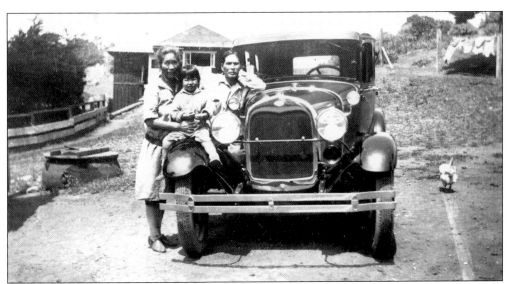

In this photo from the early 1930s, Gennosuke and Fuku Kodani are pictured with their youngest son, Eugene, sitting on the fender of their 1928 Model A Tudor Sedan. Along the path, leading to the guesthouse behind them, is a large cast-iron, whale oil–rendering pot left over from the whaling operation. There is a glimpse through the trees of the Big Dome. The chicken is one of a flock that the family kept to provide fresh eggs and meat. (Kodani family collection.)

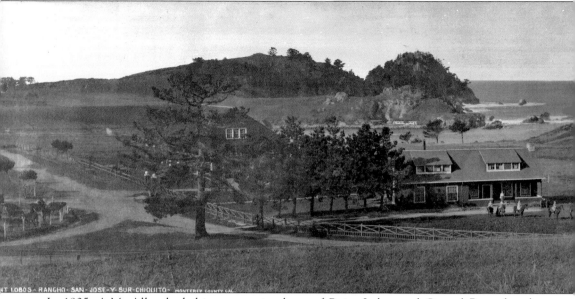

In 1905, A.M. Allan had this panoramic photo of Point Lobos and Carmel Bay taken by Prentiss & Hart of San Francisco. The dairy cattle are on the left by the crossroads to Big Sur and Point Lobos. The large barn is visible through the trees next to the Big House, where the Allan children and friends are mounted on horseback. In the background, a large shed and

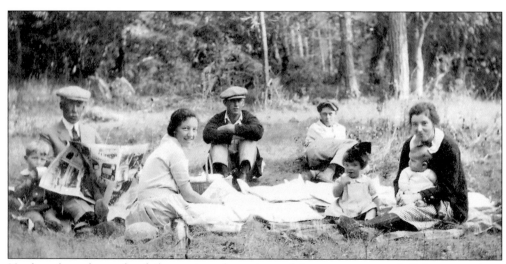

Hard work made up the daily routine of running a dairy, a cannery, and diving operations. Living on a ranch meant doing without a lot of city comforts; however, the Point Lobos families took time to enjoy the paradise in which they lived. Here the Allan family is having a picnic c. 1921. From left to right are the following: grandson Allan Hudson; A.M. Allan; daughter Margaret Allan Hudson; son-in-law Tom Riley; Tom's brother Charlie; grandchildren Helen and Julian Burnette; and daughter Helen Allan Burnette. (Allan family collection.)

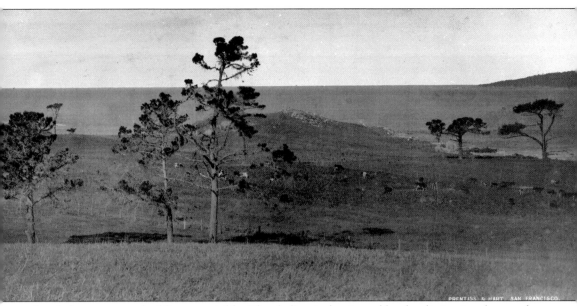

the abalone cannery building are visible. The skyline is dominated by the distinctive shapes of Whalers Knoll and the Big Dome. Carmel Bay stretches to the right, where it borders on Pebble Beach. (Allan family collection.)

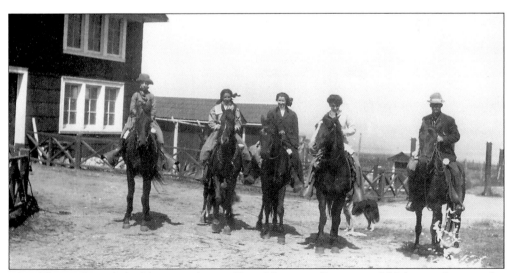

The Allan girls each had her own horse. Here Margaret, Eunice, and Helen are leaving the large barn on the left for an outing with longtime friend and schoolteacher, Miss Erma Frank, and their father, A.M. Allan, c. 1912. (Allan family collection.)

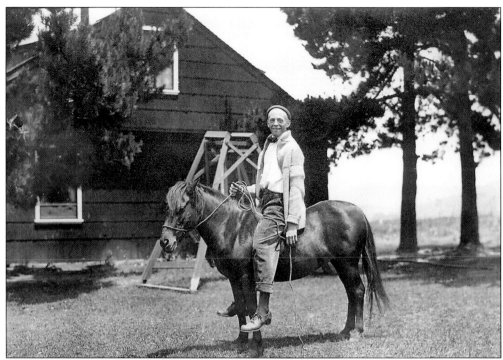

In this photo taken sometime before 1920, Mr. Bentley, the longtime ranch hand and handyman for Mr. Allan, is clowning around, riding a pony bareback. He and his mount are in front of the Big House. (Allan family collection.)

Dressed for town in this c. 1912 photo, Eunice and Margaret set out in the horse-drawn buggy. With them is Jean Elliot, who was orphaned on a nearby property and became the ward of Mr. Allan. She was lovingly raised by the Allan girls in their own motherless household. (Allan family collection.)

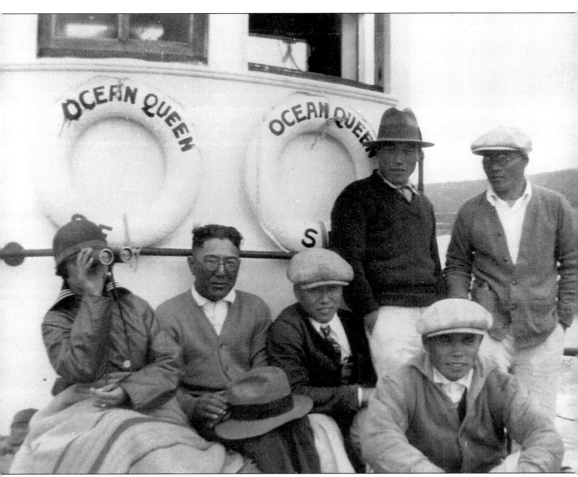

Outings on the *Ocean Queen* were particularly popular. Mary Riley was just nine years old, but she remembers sailing on the Ocean Queen from Point Lobos toward Big Sur to welcome the U.S.S. *Constitution* on October 1, 1933. "Old Ironsides" was on a goodwill and fundraising cruise from Boston to Seattle via the Panama Canal. She spent two days in Monterey and was greeted by countless boats on the way. This photo, taken in the late 1920s, shows a group of Japanese divers and friends on an outing. (Kodani family collection.)

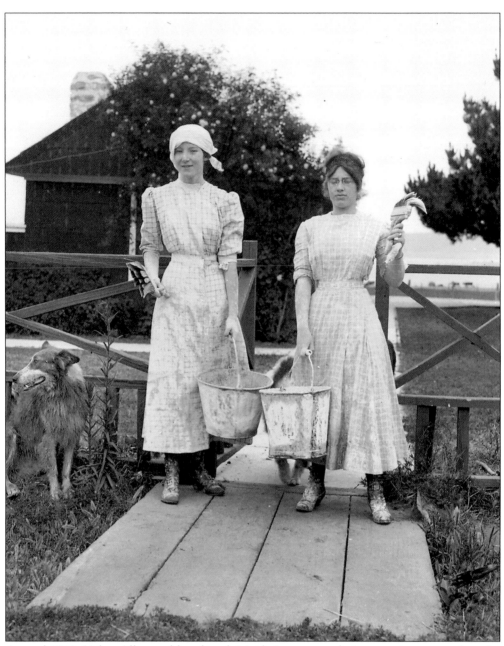

Around 1910, Helen Allan and her friend, Maida Lyons, put their spare time to good use by helping with the many ranch chores. Here they are, bucket and paintbrush in hand, on their way to whitewash the dairy. Whitewashing the buildings was needed at regular intervals. In the 1927 diary entry of Helen's husband, Julian Burnett, is a recipe for a more durable paint, used on the buildings of the ranch and cannery: 20 gallons fish oil; 400 pounds white lead; 1 pound lamp black, ground in oil; 5 pounds yellow ochre; and 1 ounce Venetian red. (Allan family collection.)

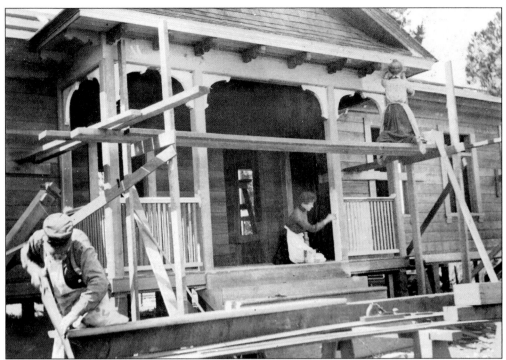

It was crucial to A.M. Allan's many enterprises to have competent men working for him. A solid house for his ranch milker would be a real incentive for a good man to stay on the ranch. One competent hired man, Tom Riley, was to become his son-in-law. Here the milker's house is being improved and repainted, with the women working on the whitewashing. (Allan family collection.)

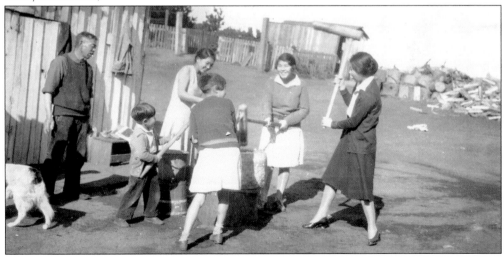

Holidays at Point Lobos incorporated age-old traditions brought from Japan. No New Year celebration would be complete without mochi to assure good luck for the coming months. The sweet rice cakes were made from smooth paste, created by pounding white rice in a tub. In this 1935 photo, the young girls and children are getting a chance to try their hand at mochi-making. One of the divers watches them closely. Traditionally, it is a man's job to pound the paste. (Kodani family collection.)

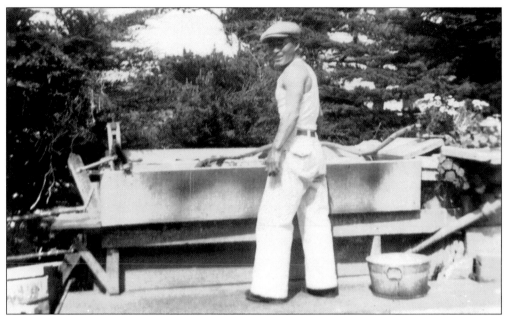

Doing laundry in the Japanese village in 1935 was an outdoor affair. The divers, being mostly single men, did their own washing. Here is Yasuda-san alongside the large wooden wash trough. On the right side, water is piped to the tub and is added by means of a hose. On the left side, a device is mounted to wring out the wet laundry before it was hung out to dry. (Kodani family collection.)

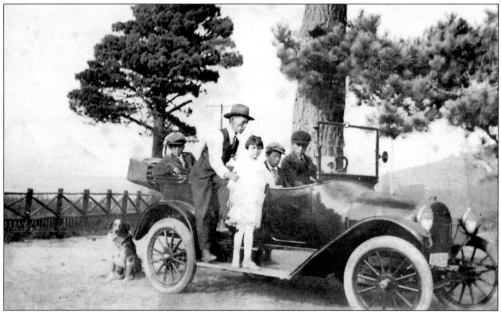

It was a special treat for Monterey families to come out to Point Lobos and enjoy the Kodani family's hospitality. One of the highlights of such a visit was the Japanese soaking tub, which was freshly filled and heated every evening. These friends are arriving in a 1915 Maxwell Model 25 touring car. Maxwells were very popular cars that competed with the Ford Model T. (Kodani family collection.)

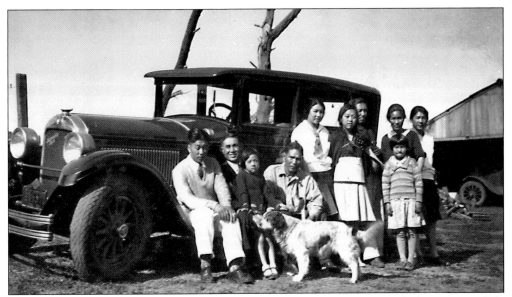

The running board of the 1926 Studebaker Big Six Sedan made a good place to sit while waiting for the rest of the family to get ready for an outing. The Kodani family dog, Luke, makes sure he is not left behind. (Kodani family collection.)

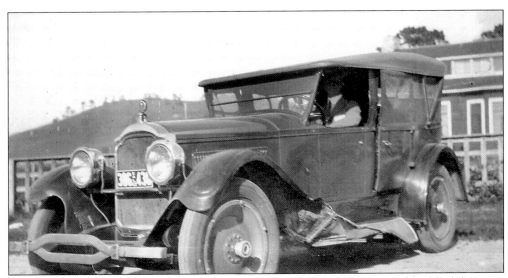

A.M. Allan was involved in many business ventures all over California and he liked driving a Packard to attend to his business. In those days, the roads were often rough and family history has it that, when distracted, he would drive off the road into a field and back onto the road. The running board of his 1924 Packard seven-passenger touring car is a reminder that this car might have been along on one of these off-road excursions. (Allan family collection.)

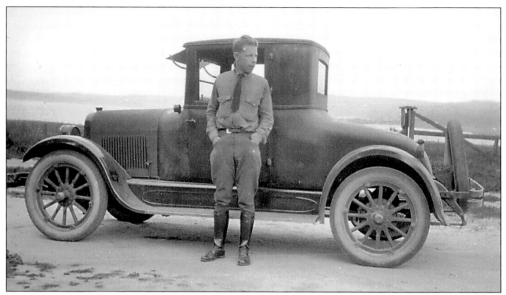

Allan's youngest daughter, Margaret, married her Pacific Grove High School sweetheart, Lester Jay Hudson. In this 1924 photo, Hudson is standing next to a 1924 Dodge Business Coupe near the gate to Point Lobos, dressed in riding clothes. (Allan family collection.)

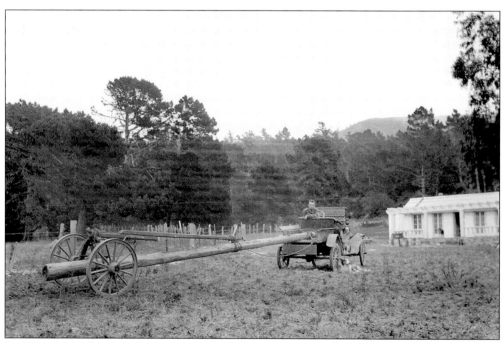

In 1924, Mr. Allan was improving the old Garcia house on his property to get it ready for himself and his soon-to-be wife, Florence. They were married on New Year's Eve of that year. Here is his son-in-law, Julian Burnette, hauling a pole for construction of the water tower behind the home. (Allan family collection.)

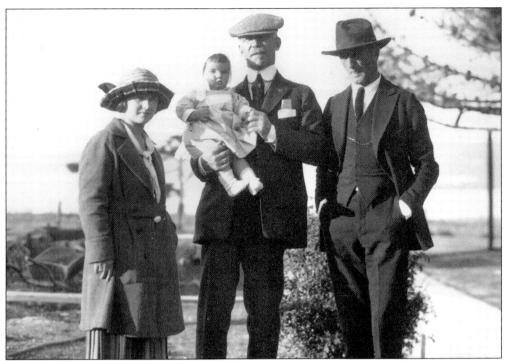

Many years after the death of his wife, Satie, and after his three daughters had started their own families, A.M. Allan remarried. Here he is pictured in 1926 standing outside the Big House with his young wife, Florence Macrae, and an unidentified man. Allan is holding his long-hoped-for son, Alexander McMillan (Bobby) Allan Jr. (Allan family collection.)

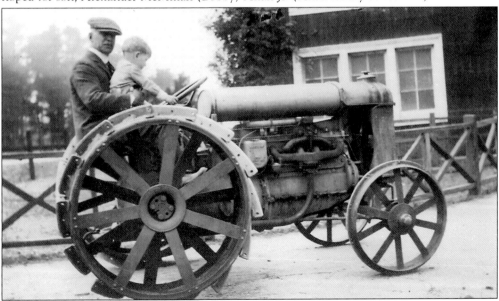

A.M. Allan gives son Bobby a ride on the Fordson ranch tractor in front of the Big House in 1928. Even though his daughter, Eunice, and her husband, Tom, had taken over the ranch operation, he liked to keep a hand in the action and no one was ever too young to be exposed to a taste of work. (Allan family collection.)

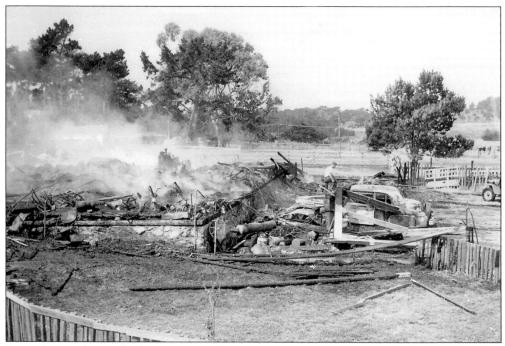

In 1949, tragedy struck when an arson fire consumed the big barn quickly. Inside, Tom Riley had a whole truck full of carrots for his cattle. By morning, they were cooked. The buggy and Margaret's Lincoln Continental were casualties, as well as many of her family's belongings that had been temporarily stored in the barn. Here Margaret's son, David, is searching through the rubble. The smoke is still rising. (Allan family collection.)

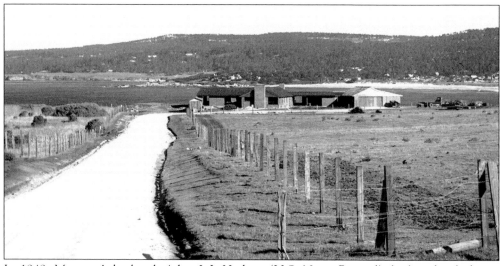

In 1949, Margaret's husband, Adm. L.J. Hudson (U.S. Navy, Retired), built a family home on the ranch. They chose the rocky outcropping set back from Moss Beach for its location. This 1951 photo shows the finished house, with the tool shed and equipment still around the outside. Hudson House still stands at Point Lobos. (Allan family collection.)

Still young and energetic, the retired Admiral Hudson enjoyed his large workshop, where all sorts of mechanical experiments took place. Here he is behind his shop, trying out a novel way of splitting firewood. He used a special ice wedge, made by Thor Manufacturing, and adapted it to a jackhammer to make the job easier. This photo of his "invention" was featured along with an article in *Popular Science* magazine in the early 1950s. (Allan family collection.)

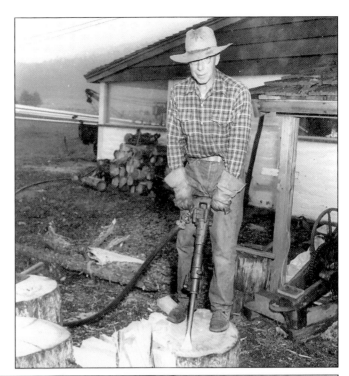

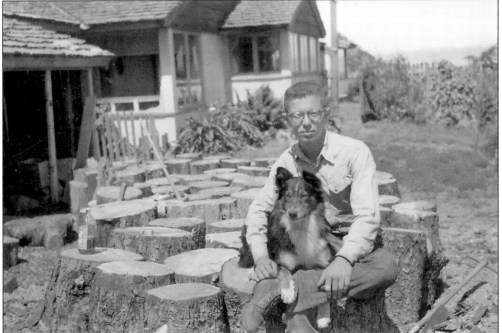

Children of all ages were expected to help with the work. While going to Carmel High School, Margaret's son, John, helped with the building of the new house. In this 1953 photo, he and his dog, Shep, are taking a break from splitting wood. Behind him is a view of the kitchen of his parent's new house that has a 180-degree view of Point Lobos and Carmel Bay. (Allan family collection.)

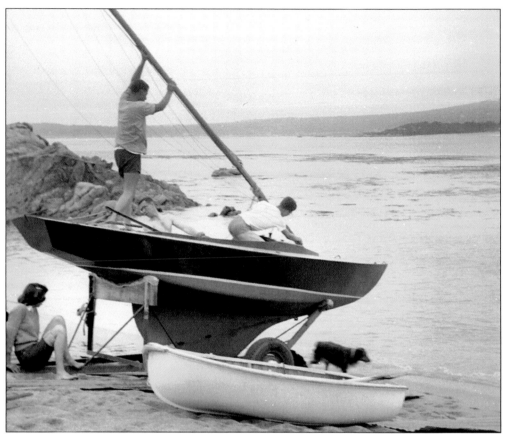

In 1951, Margaret's son David got a Mercury sailboat. Taking time out from chores, he is launching it on the south end of the San Jose Creek beach with the help of his brother, John, under the supervision of their father, the admiral. Cousin Betty Riley is sitting on the trailer tongue helping to balance the load, while Shep is checking on the surf. They kept the boat anchored in Whalers Cove. (Allan family collection.)

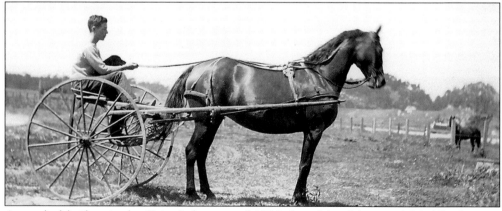

A wonderful gift arrived at Point Lobos around 1936. Aunt Mary Morgan, A.M. Allan's sister-in-law, sent this beautiful saddle-bred horse to the family. Sunset was a great riding horse and was also trained to pull a cart. He quickly became a favorite. Here Margaret's son Tom is trying out his driving skills. (Allan family collection.)

Six

CHILDREN AT THE POINT

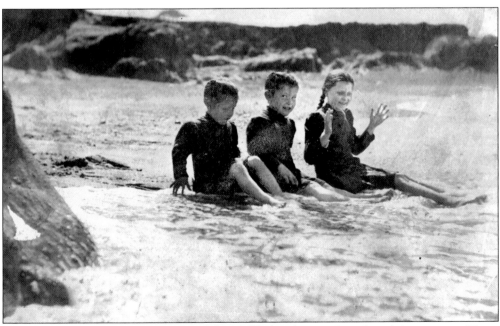

To grow up at Point Lobos meant a childhood filled with animals and outdoor activities. There were horseback rides and picnics. The fun included outings by boat, buggy, or on horseback. The ocean was so close that learning how to fish and hunt in the tide pools was a regular adventure. Here, playing on the beach, are Eunice, Helen, and their cousin Margaret Secor, in the surf at Moss Cove, c. 1902. They are delighted as the cold waves wash over their bare legs. (Allan family collection.)

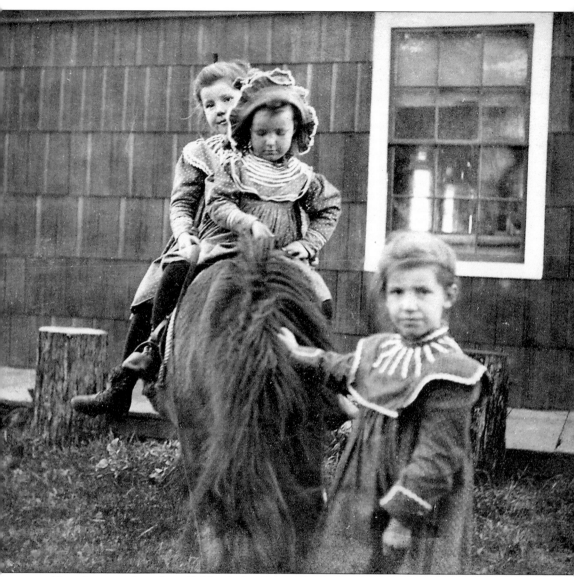

After the move here from Oakland, the three Allan girls adjusted quickly to their new life on the ranch. They loved animals and always had dogs, cats, and horses. Like all ponies, their new little mount loved to eat, never missing an opportunity. Here the pony is grazing while Eunice is petting it and Helen and little Margaret are riding double. They are in front of their first little schoolhouse next to the Big House, c. 1899. (Allan family collection.)

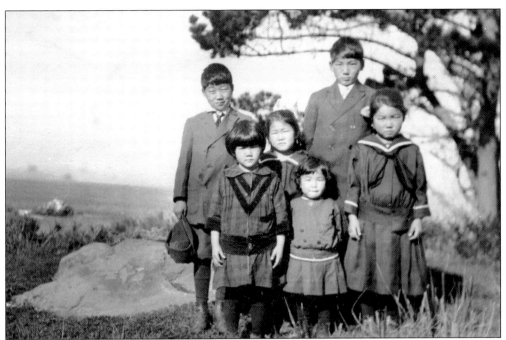

In their Sunday best, six of the Kodani children pose for a picture near Granite Point *c.* 1930. Beautifully dressed, the girls in fashionable sailor outfits and the boys in dark suits, white shirts, and ties, they make a handsome group. This picture might have been taken just before Sunday school, which was held every weekend at Point Lobos. (Kodani family collection.)

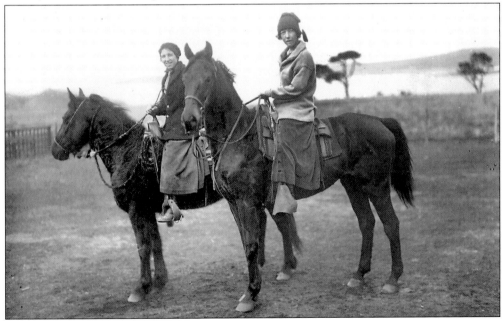

The younger two Allan girls were barely a year apart in age and were inseparable. On horseback they visited friends, explored the ranch, played, and went to school together. Here, Margaret and Eunice are dressed in long riding skirts, warm sweaters, and woolen caps against the cold wind coming off Carmel Bay, *c.* 1911. (Allan family collection.)

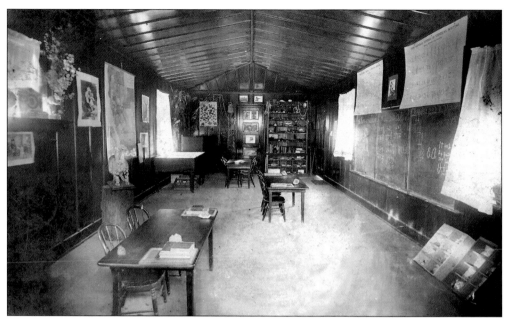

The remote and often inaccessible location of Point Lobos made it necessary to provide schooling for the ranch children nearby. This is the interior of the schoolroom that was outfitted in the little building next to the Big House. It served from 1900 until 1908, when it burned down. (Allan family collection.)

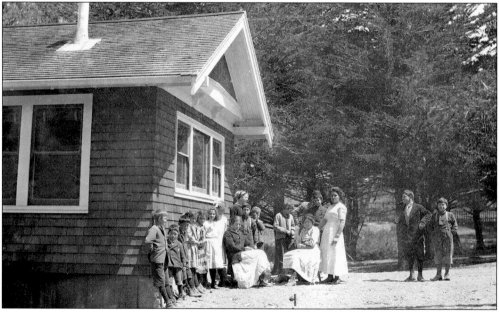

Bay School was built to accommodate the children living south of the Carmel River; the nearest school to the south was at Notley's Landing at Palo Colorado Canyon. High school meant a trip over the hill, to Pacific Grove or Monterey. In this photo, dated c. 1908, the children, who range from the first through eighth grades, are in front of the school during recess. George and Hideo Kodani are second and third from left. Eunice Allan is seated on the left. (Allan family collection.)

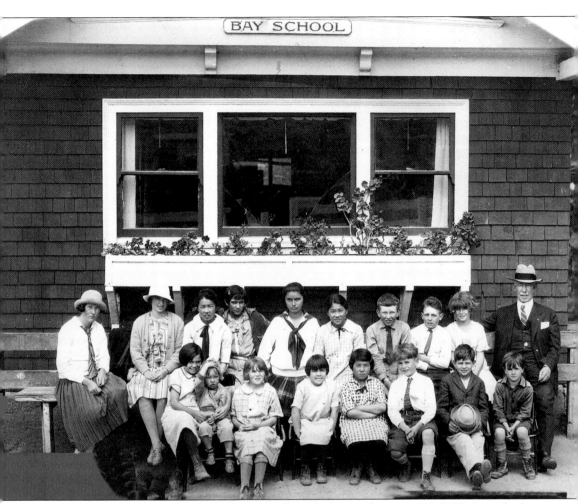

This very formal Bay School photo of Miss Hollis's class was taken in 1926. J.W. Gregg built Bay School in 1879. Ten years later, he sold the school to the county for $5 in gold. The children either rode on horseback or walked to school. While Seizo Kodani was a student, he had the daily job of carrying drinking water for the children from the Allan ranch. The pupils of the seventh and eighth grades stayed behind after class for clean-up duty. The school was distinguished by its multi-ethnic diversity, with children whose last names were Castro, Odello, Morales, Kodani, Riley and MacDonald. A.M. Allan, who had "adopted" the school, sits on the right. (Harrison Memorial Library.)

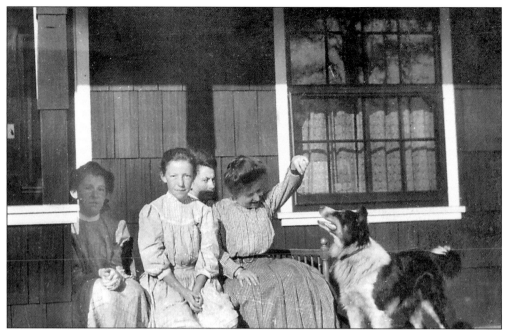

It proved difficult to attract teachers to this remote location, so as an added bonus, room and board was offered by one of the families. This arrangement appealed to many young female teachers just graduated from the teachers college. Here, on the porch of A.M. Allan's Big House, *c.* 1910, are the following, from left to right: his daughters Helen and Margaret; Ms. Reed, the schoolteacher; and an unidentified friend in back. Ms. Reed was living in the Allan household. (Allan family collection.)

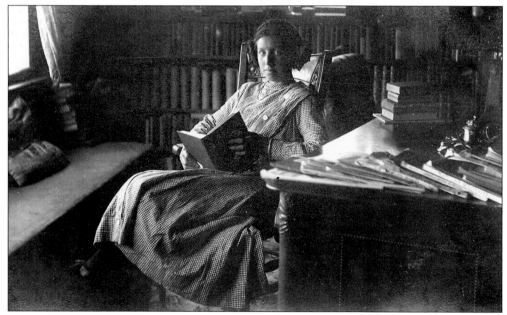

The Allan household always had a good supply of books and magazines, and all three Allan girls were avid readers. Here is Eunice in 1911 in the large living room of the Big House enjoying a book. (Allan family collection.)

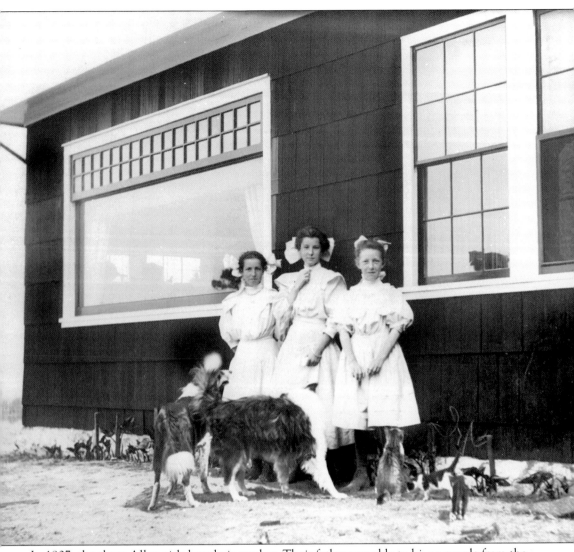

In 1907, the three Allan girls lost their mother. Their father was able to hire a couple from the Japanese village to help with the household. Decked out in their white dresses, hair ribbons, and laced boots, the girls are photographed, c. 1910, in front of the Big House along with their beloved collie dogs and ranch cats. Note the large view window that Allan had just installed in his living room to take advantage of the beautiful view of Point Lobos. (Allan family collection.)

Horses played an important role in the lives of the three Allan daughters. There was always a trusty steed to teach the new generation the ropes. Here Margaret's son Tom is getting ready to practice his cowboy skills. He is photographed, c. 1935, outside the front door of the Big House, which had now been faced with stone. Today, it is referred to as the Stone House. (Allan family collection.)

Gibson Beach, Point Lobos' southern boundary, was the perfect playground for Cynthia Williams, whose family's home overlooked the beach. This photo of Cynthia and her Terrier dog, Bido, was taken in 1926. It was made into a stereopticon card for three-dimensional viewing. (Williams family collection.)

Gennosuke and Fuku Kodani had decided to make a new life in America and both always wore western dress. Mrs. Kodani had brought a kimono with her from Japan and it was a special treat for her daughters to dress up in it. Here Takeko Kodani is standing in front of the family home at Point Lobos' Japanese village, wearing her mother's kimono. (Kodani family collection.)

As a teenager, George Kodani acquired a camera, and his family and neighbors became ready subjects for the budding photographer. Little Eugene (with his ball) and Satoko, (running with her book) were frequently photographed by their older brother. (Kodani family collection.)

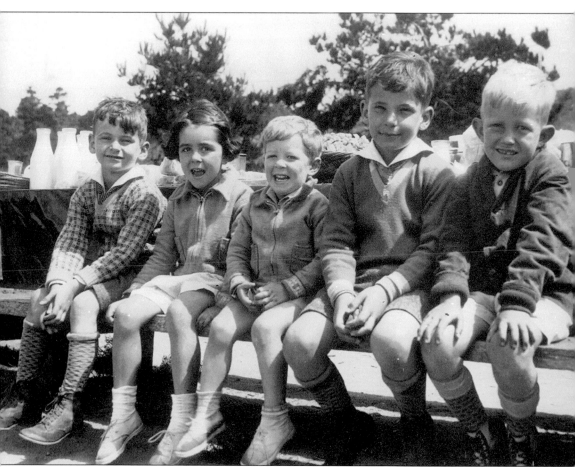

Special events, such as birthdays and holidays, were celebrated by the ranch families with picnics. This little gang of five ranch children is lined up, sitting on a bench, anxiously waiting for lunch to be served during an outing at Point Lobos. Behind them the table is laid with food and drink for a large party. Note the milk bottles to the left. At the time of this photo, around 1933, Tom Riley delivered milk from the Point Lobos Dairy to the ranch homes and to the Carmel Highlands. His daughter, Mary, not pictured here, often went along on these morning outings. From left to right are the following: unidentified, Freda Rutledge, unidentified, Fred Rutledge, and Bobby Allan. (Harrison Memorial Library.)

Growing up in a fishing village, the children learned to catch their own fish. The two girls, Yoshi Kodani and her friend Seiko, equipped with a pole, stand along the cliff overlooking Whalers Cove. Across the water is a good view of the Point Lobos Cannery, with the granite quarry behind it, and the almost treeless top of Whalers Knoll above. (Kodani family collection.)

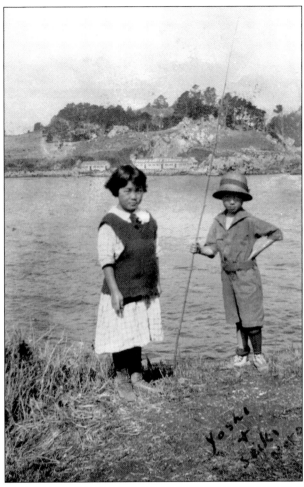

The shallow pond outside the Big House provided endless diversions. Here A.M. Allan's grandchildren, Allan and Tom Hudson, and Mary Riley make the most of the recently filled pond. The fun would usually last only about three days before the ducks discovered it, at which point it needed a good cleaning. This photo dates from c. 1930. (Allan family collection.)

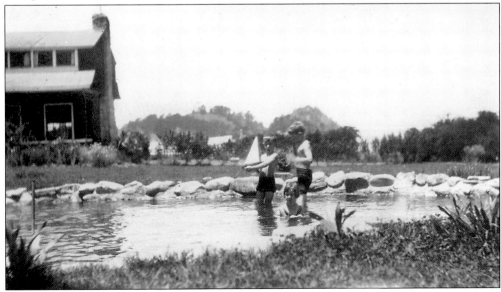

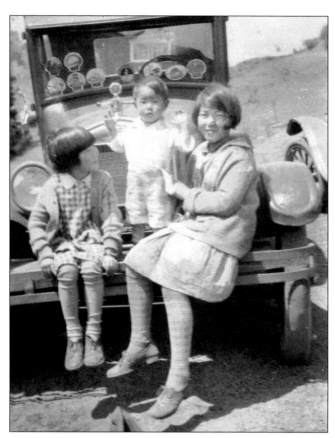

The last of the nine Kodani children, Eugene, was a joyous and lively boy. Keeping him safe and out of trouble was a full-time job. Here his sisters, Yoshi and Takeko, use the front of the 1926–1927 Model T Ford to entertain their little brother. Mounted on the badge bar across the windscreen are a series of commemorative badges, also known as grille badges, issued by automobile clubs and other organizations. (Kodani family collection.)

In 1933, the Whalers Cabin was home to Mr. Rutledge and his family. He was the hired man for the ranch. Here his children, Freda and Fred, sit on the back bumper of their father's 1928 Model A Tudor Ford Sedan. (Harrison Memorial Library.)

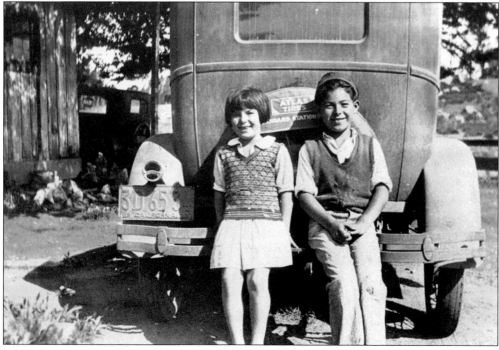

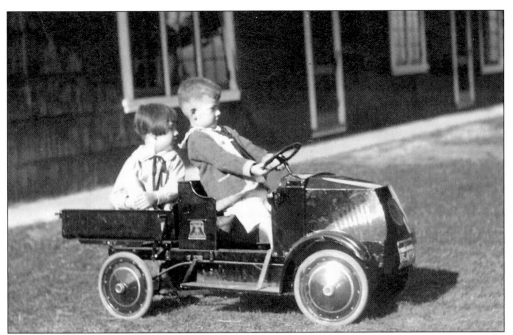

As time went by, Allan's grandchildren began to repeat the cycle of growing up on the ranch. Cars had become part of everyday life and here Little Helen and Julian Burnette Jr. play in their own toy car in front of the Big House, c. 1926. (Allan family collection.)

Fusako Kodani and Jean Elliot, who grew up in the Allan household, spent long hours together. Their favorite pastime was staffing the gate to Point Lobos and collecting the 50¢ toll per car. Dressing up in matching clothes provided endless entertainment. They must have felt like twins with the ribbons in their hair, even if the jumpsuits did not fit perfectly. This photo was taken c. 1920. (Kodani family collection.)

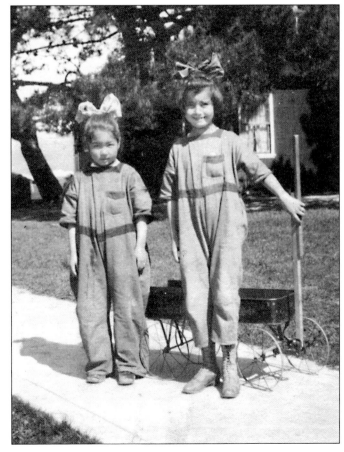

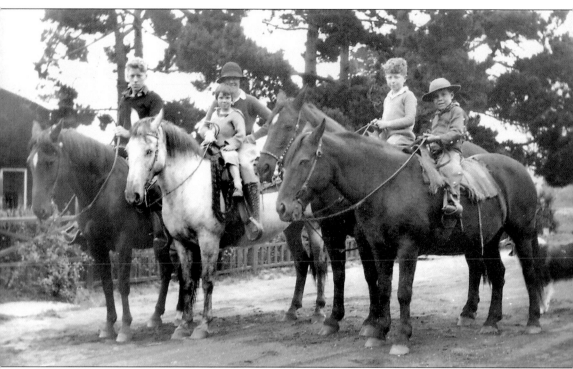

Allan's daughter Margaret loved to introduce the next generation to the pleasures of horseback outings. The ranch provided lots of variety for riders of any ability. The trail along the San Jose Creek into the canyon was a favorite, and the view from Michael's Hill was worth the climb to the top. The beaches stretch for miles north to Carmel, and Point Lobos was their front yard. When this photo was taken around 1928, Margaret and her group are in front of the Big House outside the distinctive redwood fence. From left to right are Pete Collins, Margaret with Mary Riley on her horse, sons Allan and Tom Hudson, followed by a trusty sheepdog. (Allan family collection.)

Seven

VISITORS AND GUESTS

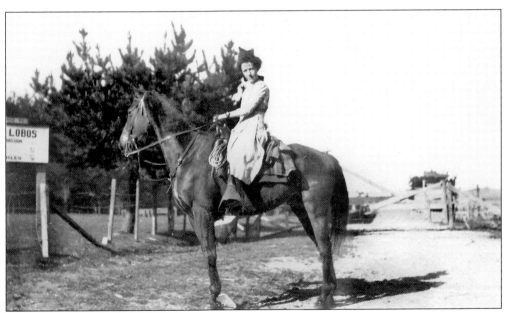

A.M Allan quickly became aware of the attraction of his property to outsiders. To exercise some control and generate income, he put up a gate in 1899 and charged a toll. His children and grandchildren remember manning the gate to let visitors in and out and collect the 50¢ toll. In this *c.* 1911 photo, his daughter, Eunice, is on horseback in front of the gate. Note the entrance sign with fees posted to the left. (Allan family collection.)

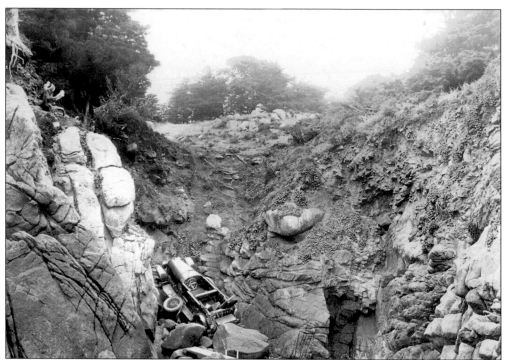

On July 20, 1924, this lovely Marmon touring car carried a happy family to the Point for a picnic. Such a good time was had that nobody noticed that the hand brake was not set properly and the car, complete with bassinet and baby in the back seat, rolled down the steep rocky slope toward the ocean. Fortunately, the baby landed on a little patch of beach sand and only had a little scratch. The car, however, did not fare so well. (Allan family collection.)

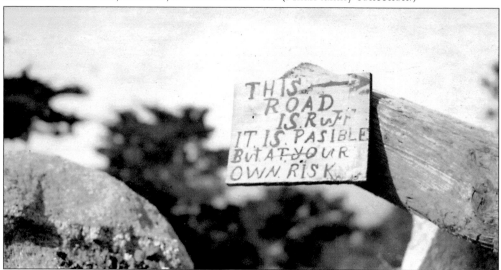

This sign was photographed between 1918 and 1920 by William Ireland. He was a San Francisco photographer, painter, and insurance agent. Drawn to this beautiful area as a photographer and painter, he must have been aware, as an insurance man, of the liability reason for the sign, and amused enough by the spelling to leave us this wonderful photographic record. (Charlotte Boyd Hallam collection)

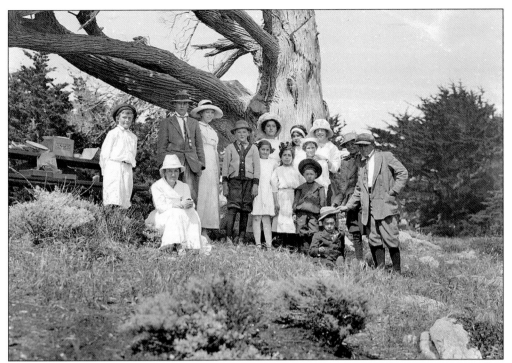

Most of the younger generation along for this picnic was rounded up for this c. 1920 group shot in front of a dead cypress tree. Everyone is in Sunday best, white dresses for the girls and ladies, suits for the boys and men, and hats for everyone. (Allan family collection.)

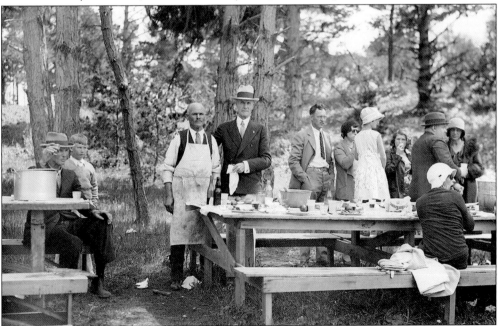

This photo of a typical weekend outing was taken in the early 1900s. Not all groups were this organized. These visitors brought everything with them for their lunch: pots, pans, and place settings. (Allan family collection.)

In 1904, the White family came to Carmel from Chico, California, for the health of the baby, Mariam, pictured here the same year at Point Lobos. Her mother, Sarah, holds Mariam's hand, and Aunt Margaret sits looking away from the camera. Note the bare rocks and the beautiful clothes worn to attend picnics. (Mariam Melendez collection.)

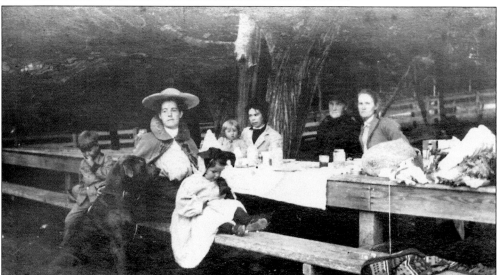

This photograph was taken c. 1907 of the White family, who were frequent visitors to Point Lobos. This picture shows mother, Sarah, with young Mariam and their dog, Prince, on the bench in front. To the far right is Aunt Margaret, who around 1912 used to bring her organ to Point Lobos to play for the Japanese children's Sunday school. The other people in this photo are unidentified. (Mariam Melendez collection.)

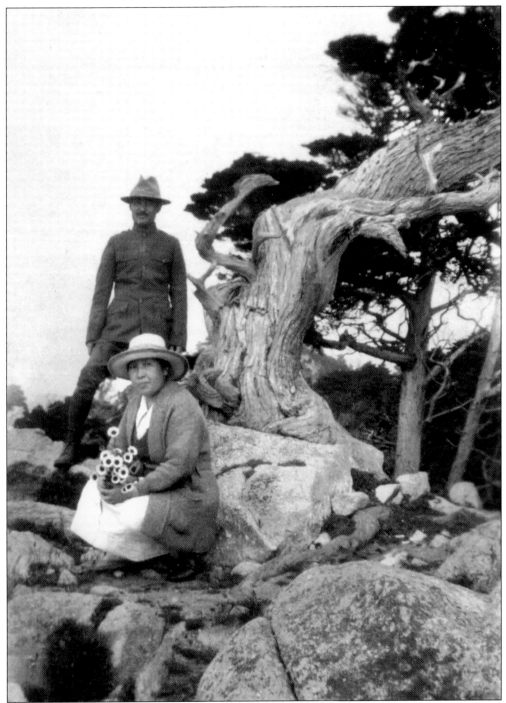

These unidentified guests of the Kodani family were photographed during a break from a walk through the Cypress Grove. Unwittingly, the couple forms an appealing composition; the woman sits with her bouquet of seaside daisies, the man wears what appears to be a World War I uniform. Both are offset against a twisted cypress tree, for which the grove is famous. (Kodani family collection.)

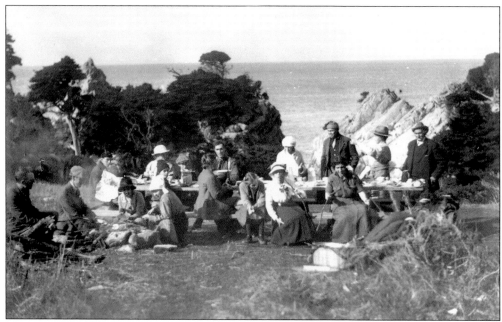

Here a group of picnickers are gathered at the tables set up overlooking Pinnacle Point on Cypress Grove in 1905. Long sticks are used to barbeque over the open fire. It was the job of the Allan and Kodani families in the evenings to make sure all campfires were completely out to prevent wildfires. (Pacific Grove Museum of Natural History.)

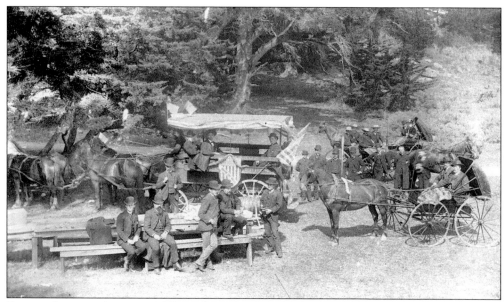

During the years between 1887 and 1895, photographer C.W.J. Johnson was working in Monterey. He took this photo of members of the Monterey Plumbers Association during their picnic held at Point Lobos' Cypress Grove. (Monterey Public Library.)

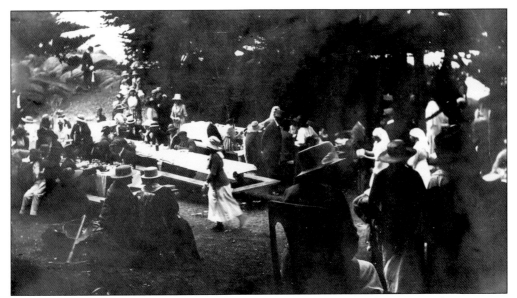

A.M. Allan was involved in many local civic affairs and he made his Point Lobos property available for a great many events and fundraising activities. For example, this picture was taken during a Red Cross benefit held at the Cypress Grove during World War I. On this occasion in 1917, the host prepared an abalone feast. A number of the guests are wearing traditional nursing uniforms. (Allan family collection.)

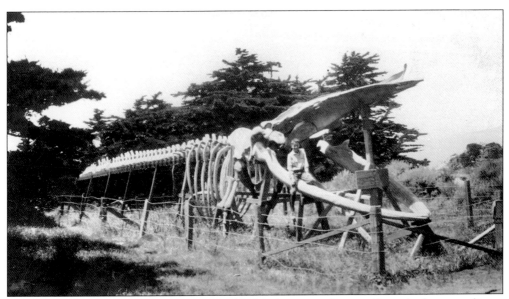

This skeleton of a fin whale had been assembled and set up at Cypress Grove by Japanese divers. The dead whale had washed ashore, was buried, and the skeleton unearthed some months later. It was a tourist attraction and here Cedrick Rowntree, son of botanist Lester Rowntree, poses for this c. 1925 photograph. (Harrison Memorial Library.)

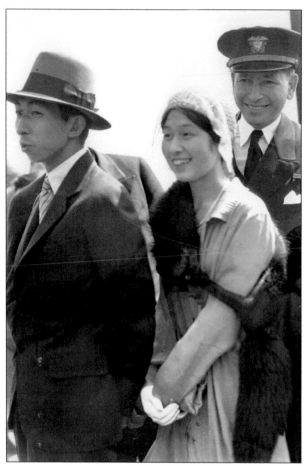

Princess Kikuko, wearing a mink wrap, and her husband, Prince Takamatsu, circulate among the guests at their May 1931 visit to Point Lobos. A great many people in the Japanese community were invited to greet them. A previous royal visit in 1925, unheralded by the press at the request of the royal couple, Prince Asaka and Princess Nobuko, involved a spontaneous picnic at Point Lobos for 200 guests. (Photo by Julian P. Graham, courtesy of Harrison Memorial Library.)

It became a tradition for Monterey Peninsula community groups to organize picnics at Point Lobos. It was an ideal one-day outing. First came the beautiful drive over Carmel Hill or through Pebble Beach, going by the Carmel Mission. Lunch and a walk or outdoor games followed at Point Lobos. By nightfall everyone made it back to Monterey. Here, in this 1909 photograph, a number of horse-drawn carriages are arriving for a Japanese community picnic. (Kodani family collection.)

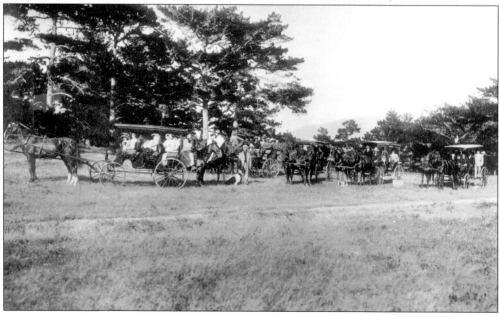

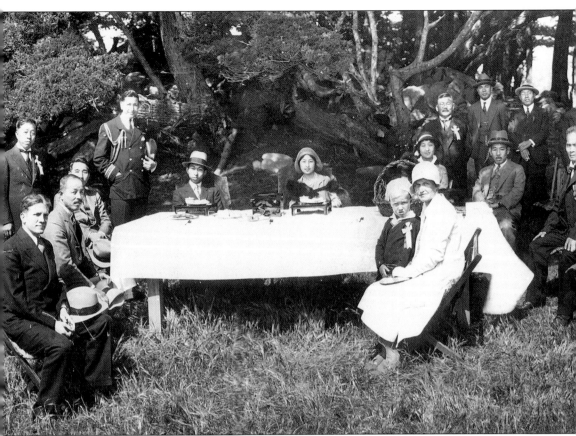

His Imperial Highness, Prince Takamatsu, younger brother of the future Emperor Hirohito, visited Point Lobos with his wife, Princess Kikuko, in May 1931. Lunch at Highlands Inn was followed by a demonstration of abalone fishing methods at Point Lobos, and then by tea. In this photograph, we see the royal couple and their entourage seated at a tea table. Florence, A.M. Allan's wife, and their small son sit in front of the table, to the right. (Photo by Julian P. Graham, courtesy of Harrison Memorial Library.)

The local newspaper was full of accounts of weddings held at Point Lobos by people from near and far. Satie Morgan Allan's sister, Mary Morgan, came out from Chicago in 1929 to have her ceremony at Point Lobos. Here she is on her wedding day, dressed in hat and furs with her bridegroom, Harry Wilson, on her right, and surrounded by family, with A.M. Allan sitting on a rock at Cypress Grove. (Allan family collection.)

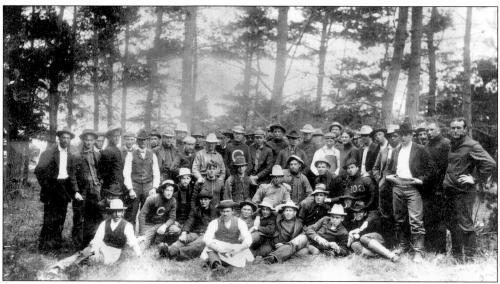

A.M. Allan invited the civil engineering class from UC Berkeley to hold their summer land-surveying camp at Point Lobos. They came for several seasons to work on a survey for a railroad from Point Lobos to Lake Majella, which is present-day Asilomar in Pacific Grove. This photo shows the class posing for a group shot in 1903. Note the man with the letter sweater in the front row. (Allan family collection.)

Eight

ARTISTIC INSPIRATION

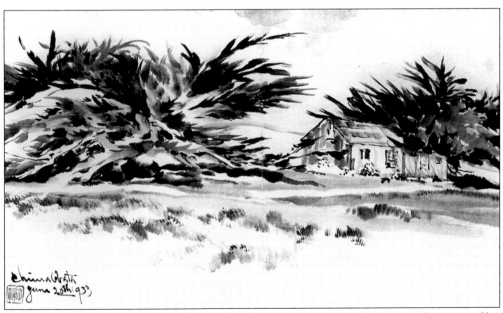

Japanese-American artist Chiura Obata, a landscape painter, worked in watercolor; some of his works were converted into woodblock prints. His favorite spots in California were Yosemite and Point Lobos, both of which inspired a lifelong reverence for nature as a powerful spiritual force that influenced both his art and his life. He and his family often stayed in the guesthouse in the Japanese village at Point Lobos. Eventually, Obata's daughter, Yuri, and Eugene Kodani were married. This watercolor of the Whalers Cabin, with its two distinctive Monterey cypress tress, was created in the 1930s. (Obata family collection.)

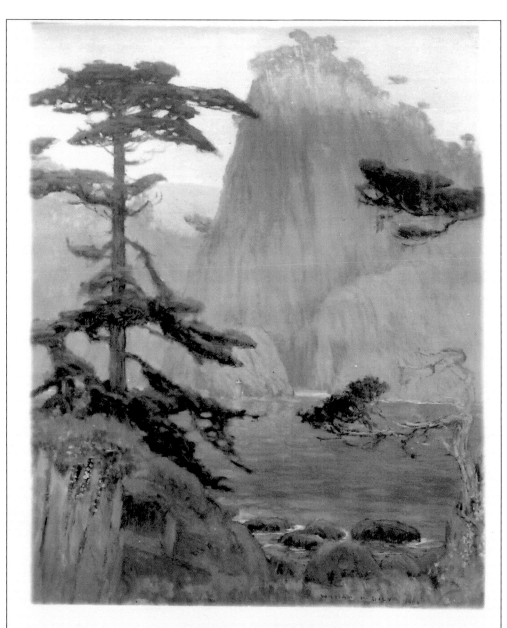

SALON DES ARTISTES FRANÇAIS PARIS 1926

L'HEURE TRANQUILLE

Pointe de Lobos, California.

par William P. SILVA

California landscape painter William Posey Silva chose this painting of the Big Dome at Point Lobos for his salon postcard when he was exhibiting in Paris in 1926. He moved from the East Coast to California in 1913 and lived here until his death in 1948. (Allan family collection.)

The Carmel Highlands, just south of Point Lobos, was home to a number of artists who thrived in this beautiful and undiscovered part of the world. Gibson Beach was an ideal place to have great outdoor gatherings to nurture the creative spirit. Members of this party from the late 1920s include, from left to right, the following: (front row) painter John O'Shea, two unidentified ladies, and Douglas Short; (back row) painter Theodore Criley is waving for the camera. (Williams family collection.)

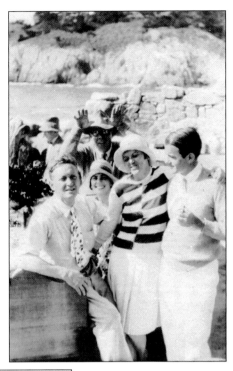

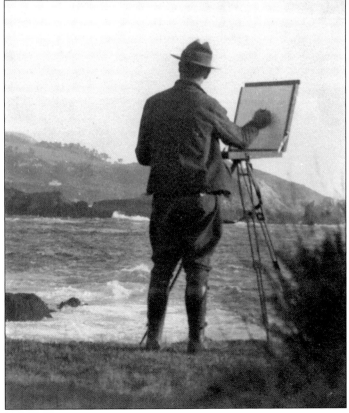

Painters John O'Shea, William Ritchell, William Watts, and Theodore Criley all lived in the Carmel Highlands. In Point Lobos, they had the most spectacular, ever-changing scenery at their doorstep. Criley's home and studio bordered Gibson Beach. In this early 1920s photo, he is working at his easel, looking toward Bird Island. (Photo by Lewis Josselyn, courtesy of the Williams family collection.)

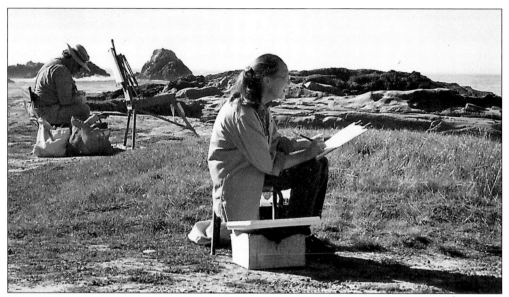

Generations of local painters have set up their easels at Point Lobos. Here, Lana Price and Dick Crispo work at Weston Beach along the south shore. Lana, who has lived just south of Point Lobos for years, comes often to paint. Dick, a member of the Carmel Art Association, works in a variety of media, and his striking murals are found at many Peninsula locations. (Photo by Monica Hudson.)

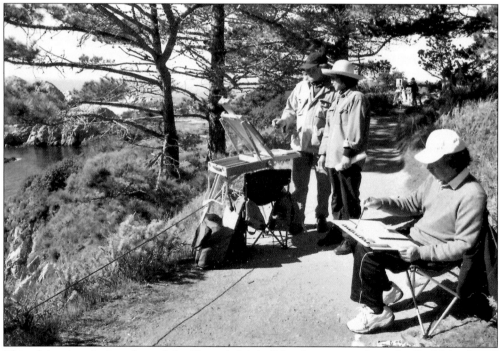

This plein-air painting class of the Carmel Adult School is set up along the Bird Island trail where it overlooks the emerald green water of China Cove. On the left is Mark Farina, the instructor, who lives, paints, and exhibits locally. (Photo by Monica Hudson.)

Poets Robert Bly and Elliot Ruchowitz-Roberts are pictured here in 2001 on the south shore with Bird Island in the background. Their love for Point Lobos is reflected in a number of their poignant poems, some of which are published in *Dancing on the Brink of the World: Selected Poems of Point Lobos.* From left to right are Robert Bly, photographer Tey Roberts, and Elliot Ruchowitz-Roberts. (Tey Roberts collection.)

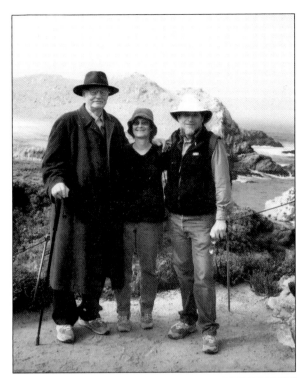

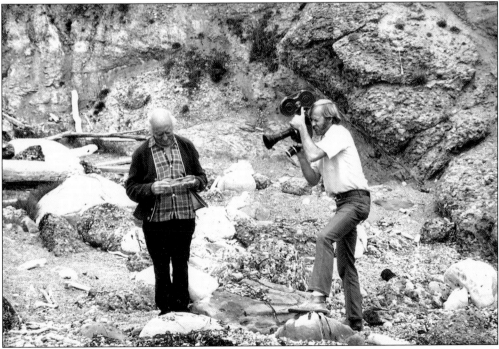

Eric Barker, born in England, came to the Big Sur coast where he made his home. Close friends with Robinson Jeffers and Henry Miller, he wrote frequently about Point Lobos. Here he is photographed by Robert Blaisdell in 1968 for the movie *Poet at Lobos.* (Robert Blaisdell collection.)

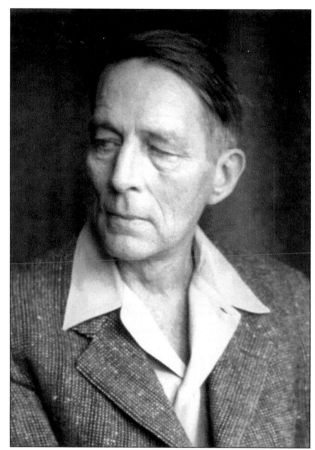

Robinson Jeffers was a celebrated poet who moved to Carmel in 1914 and remained until his death. He is pictured below during one of his frequent visits to Point Lobos. The view of the Point from Hawk Tower, where Jeffers wrote, was his daily inspiration. He described the Point in this previously unpublished essay written in 1947: "And the granite cliffs that they [the trees] grow on are like the rocks in a Chinese painting. That was my impression of Point Lobos when I first saw it—that it was Oriental, it did not belong to this country, but must have drifted like a ship across the Pacific from the headlands of Asia." (Photo by Sadie Adriane, courtesy of Monterey Public Library; prose excerpt from the Robert K. Blaisdell collection, quoted with permission by Jeffers Literary Properties.)

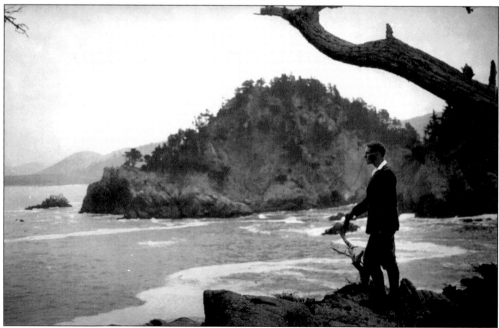

John Steinbeck asked to have his ashes scattered at Point Lobos. "John's sisters had arranged a small service for the family on Point Lobos, on a cliff overlooking Whalers Bay, a spot that John and Mary had loved and where they had played as children. A young priest . . . said the burial service, took a handful of dust and let it drift with the wind. . . . ashes to ashes, dust to dust. . . . An otter played in the sea below and, above, a gull circled and cried out against the sky." (Prose by J.J. Benson, *John Steinbeck Writing*, 1984; photo courtesy of Center for Steinbeck Studies, San Jose State University.)

Robert Louis Stevenson spent

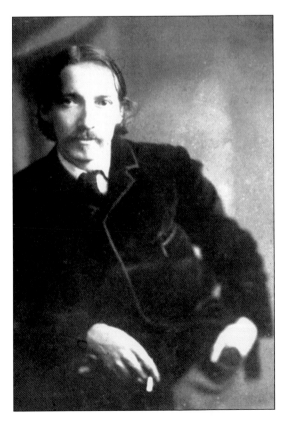

some months on the Monterey Peninsula in 1879 pursuing Fanny Osbourne, his future wife. He was fascinated by the tales of bandits, gold strikes, and buried treasure he heard in Monterey. Exploring the peninsula, he rode over the hill to the Carmel Mission, and from there saw the picturesque outline of Point Lobos across Carmel Bay. Legend has it that Point Lobos was the model for his classic adventure story, *Treasure Island*. (California State Park Collection.)

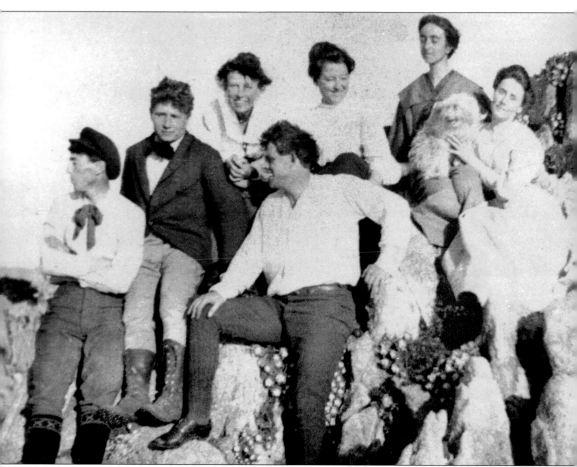

In 1905, George Sterling, unofficial poet laureate of San Francisco, moved to Carmel-by-the-Sea to escape the distractions of the city. By 1907, an artists' colony had formed around him in Carmel, with Sterling playing host. Many poets, writers, and artists came for varying lengths of time. These included Mary Austin, James Hopper, Nora May French, Sinclair Lewis, Jack London and his wife (for short visits), and Upton Sinclair (Sinclair left after a few months, disgusted by the "dissipation"). Sterling's plans for writing were indeed sidetracked by such blandishments as abalone cookouts on the beach and evenings of performance, recitation, and serious partying. In this c. 1906 photograph, taken at Point Lobos, a group of bohemian friends pose for the camera, from left to right: George Sterling, Jimmy Hopper, Charmian London, Jack London, Alice MacGowan, Mabel Grey Lochmund, and Carrie Sterling. (Harrison Memorial Library.)

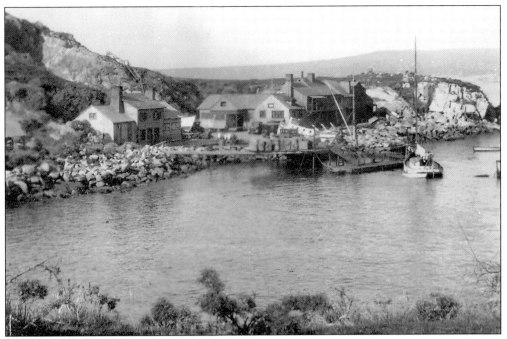

During the 1920s, Hollywood discovered Point Lobos and began filming portions of many movies there. The following photos are examples of films made at the Point. *Paddy, The Next Best Thing*, filmed in 1933, is a romantic comedy in which Janet Gaynor stars as a spirited Irish lass. The film set was built incorporating the buildings of the abalone cannery at Whalers Cove. (Allan family collection.)

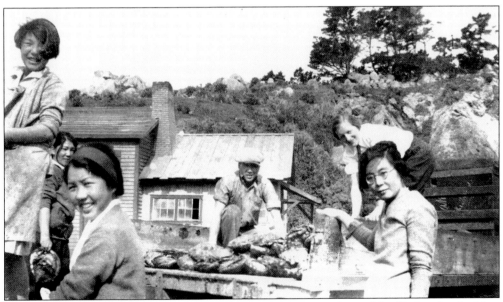

Hard at work on the set for *Paddy, The Next Best Thing* are members of the Kodani family. Here are Yoshiko, Takako, Fusako, and Seizo Kodani with two guests. They were also employed as extras during filming. (Kodani family collection.)

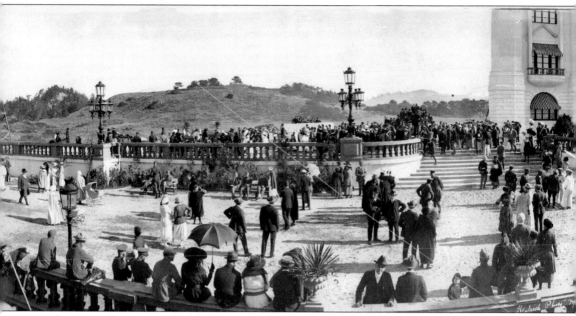

The 1922 silent movie *Foolish Wives* was directed by Erich von Stroheim and was purported to be set in Monte Carlo; however, the elaborate set that included a massive chateau was built on Sea Lion Point at Point Lobos. This was the first movie to boast a $1 million budget. The film opens with Count von Stroheim eating caviar and smoking Russian cigarettes, gazing out of his oceanside chateau. Other movies filmed in part at Point Lobos include the following: *Lassie Come Home* (1943) with Roddy McDowell and Elizabeth Taylor; *A Summer Place* (1959) with

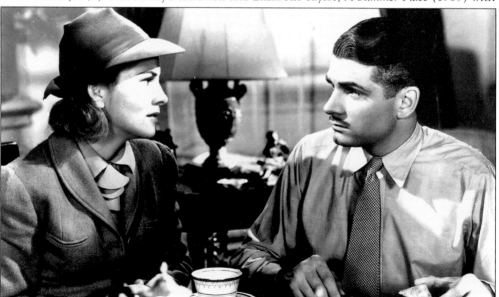

Rebecca is arguably one of the great Gothic romances in film history. Director Alfred Hitchcock filmed part of the movie at Point Lobos in 1939. It starred the incomparable Joan Fontaine and Laurence Olivier. In the South of France, Olivier's character, the wealthy Mr. de Winter, falls in love with a lady's shy companion. He marries her and brings her home to his country estate in England, whereupon a story of mystery and suspense unfolds. (Harrison Memorial Library.)

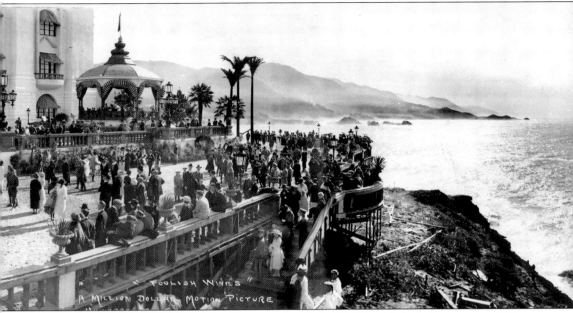

Troy Donahue and Sandra Dee; *The Notorious Landlady* (1962) with Jack Lemmon and Kim Novak; *The Graduate* (1967) with Dustin Hoffman and Ann Bancroft; and, more recently, *Turner and Hooch* (1989) with Tom Hanks. (Photo by Anton Heidrick, courtesy of Monterey Public Library.)

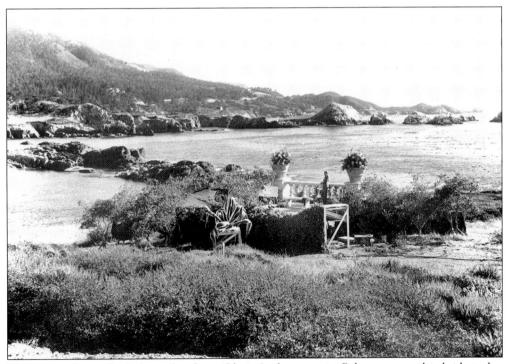

This scene shows the balustrade where Olivier's character in *Rebecca* courts his bride-to-be. Note Bird Island in the background.

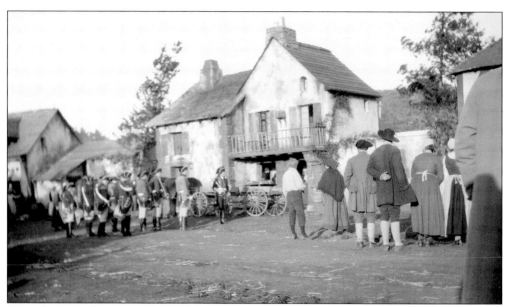

Evangeline, an adaptation of Longfellow's poem, was filmed in 1929, starring Dolores del Rio. This silent classic is the only movie filmed almost entirely at Point Lobos. The plot concerns an Acadian girl betrothed to a British immigrant whose marriage was interrupted by the onset of the 18th century war between Britain and France. The photograph shows the village of Grand Pre, Nova Scotia, built at Sea Lion Point. (Allan family collection.)

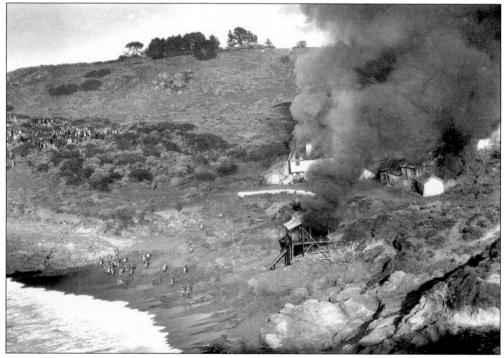

In the film *Evangeline*, the village of Grand Pre, Nova Scotia, was burned to the ground by the French. The Acadians fled to Louisiana, and Evangeline spent many years searching for her lost lover. This fire scene was filmed in Point Lobos. (Harrison Memorial Library.)

This World War II movie, *Edge of Darkness*, stars Errol Flynn and Ann Sheridan. The story concerns a Norwegian fisherman who led his village's resistance against Nazi invaders. It was partly filmed in two native Monterey Cypress stands at Pebble Beach and Point Lobos. In a more relaxed moment, Ann Sheridan poses languidly, becoming almost part of a cypress tree. (Harrison Memorial Library.)

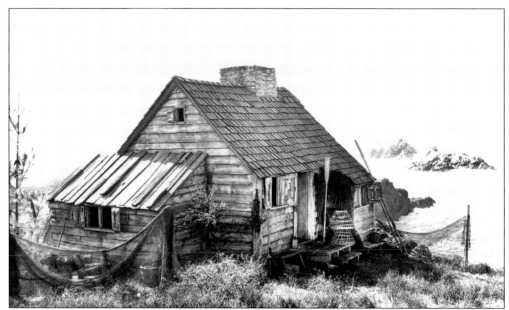

Maid of Salem, filmed in 1937, featured Claudette Colbert and Fred MacMurray. It concerned fanatical Massachusetts Puritans who lead an attack on people suspected of witchcraft in 1692. Bird Island is visible in the background. (Harrison Memorial Library.)

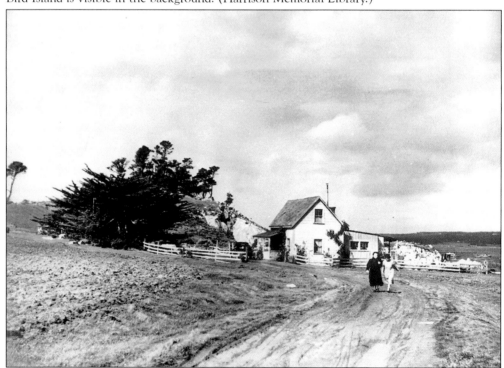

The 1934 movie *He Was Her Man* stars James Cagney and Joan Blondell. The plot involves hitmen sent after the Cagney character. He hides out with Joan Blondell at Point Lobos. This scene shows a set built for the movie, with Whalers Cabin tucked away under the cypress trees. The waters of Whalers Cove are in the background. (Harrison Memorial Library.)

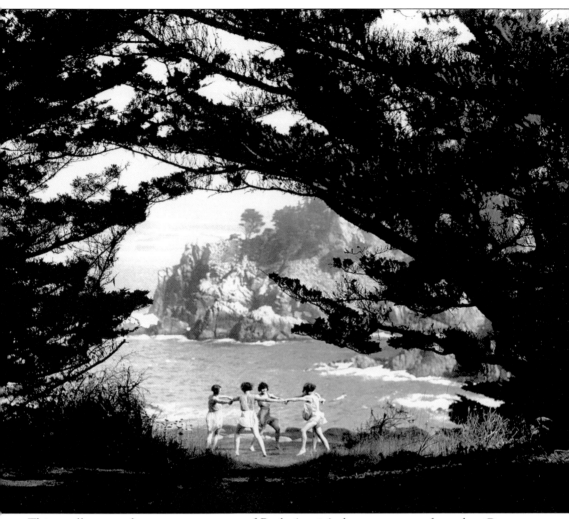

This small group of young women, part of Ruth Austin's dance group, performed at Cypress Grove. The photo comes from a one-page display in the February 1928 edition of *Game and Gossip*, entitled "Nymphs of Del Monte." The legend reads, "Like a picture of fairyland is this beautiful photo of the Ruth Austin dancers, taken in the perfect setting provided at Point Lobos." (Photo by Julian P. Graham, courtesy of Harrison Memorial Library.)

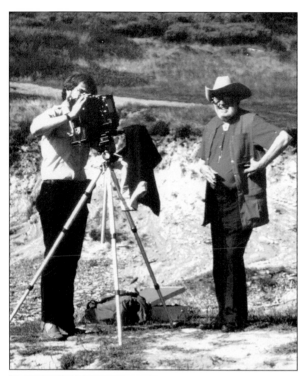

Ansel Adams, who lived the last years of his life just south of Point Lobos, was a frequent visitor. Numerous documentaries were made about him and other local photographers. This early 1980s photo along Weston Beach, taken during a film shoot, features photographers John Sexton (left) and Ansel Adams (right). (Photo by Chuck Bancroft.)

Edward Weston was the master of black and white photography. His artistic photographs of Point Lobos and the rock formations along the south shore became world famous. A documentary film was made of his work and this image of Edward Weston behind his camera captures him near Pinnacle Point, while filming the movie *The Photographer* by Willard Van Dyke in 1948. (Kim and Gina Weston collection.)

Cole Weston, Edward's son, lived most of his life just south of Point Lobos. He had a great love for theater and the outdoors, the land as well as the ocean. Point Lobos could nurture it all. His magnificent color photos of the Big Sur coast evoke that grandeur. In the summer of 1986, his photographer friend, Roger Fremier, took this photo of Cole to be used in a promotion for Cole's workshops. (Photo by Roger Fremier.)

The outdoor setting at Point Lobos is ideal for classes. In April 1987, Rod Dresser, from the Center of Photographic Art, teaches a photo workshop sponsored by Monterey Peninsula College. The model for the class, Edna Bullock, sits on the rocks at the South Shore near Weston Beach. (Photo by Roger Fremier.)

This staged picture from the 1980s was taken during a photo shoot for an Oriental Paper advertisement. The setting is an imaginary photo class taught by Bret Weston, attended by notable local photographers. From left to right are the following: advertising executive Gail Pierce, photographer Wei Chang, two unidentified persons, Bill Brooks, Henry Stricker, Roger Fremier, Scott Campbell, Elizabeth Pasquinelli, Edna Bullock, and Rosario Mazeo. (Photo by Richard Garrod, courtesy of the Roger Fremier collection.)

Tigers are not native to Point Lobos; however, this exotic visitor arrived as part of an advertising campaign in the 1970s. As the star of a commercial for gasoline, his image and the slogan, "Put a Tiger in Your Tank," were recognized worldwide. Here the model stands up against a rock, with the outline of Point Lobos behind him. (Photo by Chuck Bancroft.)

Nine

FROM PRIVATE TO PUBLIC

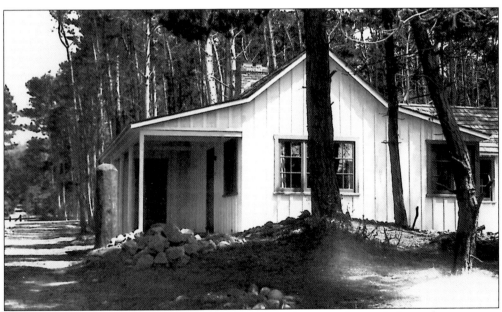

In 1933, Point Lobos became part of the new state park system. It was designated a reserve to be held in trust in its natural state. Strict guidelines were set up to govern the management of this unique property. This board and batten redwood house was the first ranger residence. It was built at the entrance to the reserve and the ranger collected the entrance fee from a bay window protruding from his kitchen. The building still functions as a residence today, but traffic is controlled by a kiosk in the center of the road at the entrance. (Photo by Newton Drury, from the California State Park Collection.)

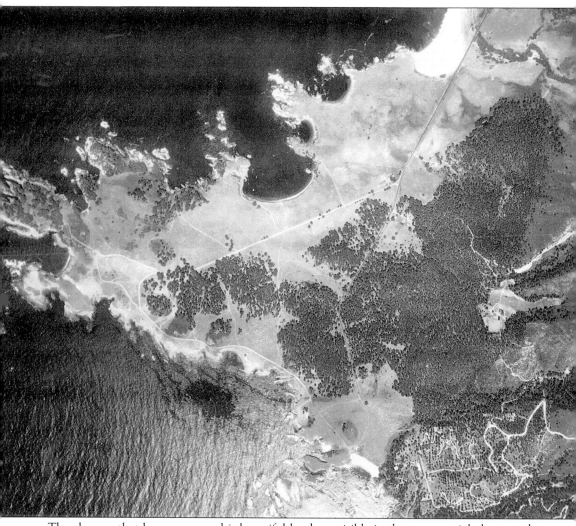

The changes that have come to this beautiful land are visible in these two aerial photographs, from the early 1920s and from 2002. The most striking difference is the open landscape of earlier times. The 1920s photo shows the tree cover consisted of mostly Monterey cypress trees on the promontories, with a stand of Monterey pines on the land side of Bassett Avenue. The avenue enters Point Lobos in a straight line from the Allan home. The coast road passes on the land side of the ranch buildings as it comes from San Jose Creek beach. It then makes a sharp turn to the south, in the forest, to reach the Carmel Highlands. That development had just been laid out and trees had been planted in straight rows. (Lana Price collection.)

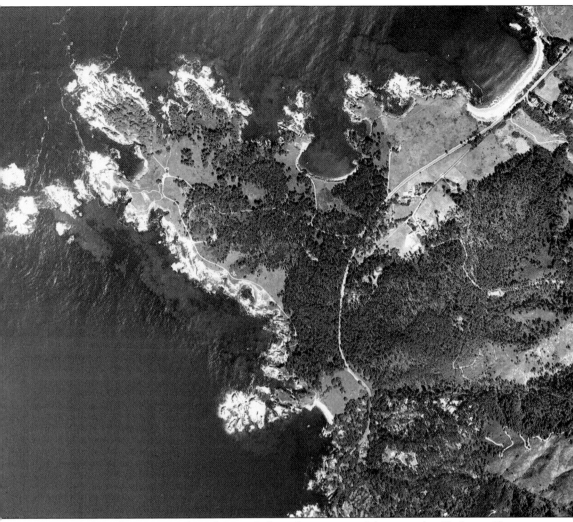

In 1933, before the state purchased Point Lobos, the coast road (present-day Highway 1) was realigned. In this photo from 2002 the new right-of-way is the most visible line. One can still see the old part of the road passing by the ranch buildings, but no trace remains of Bassett Avenue, the former main access road. With no cattle grazing the land in 70 years, the Monterey pines have advanced across most of the meadowland of the south shore, the Whalers Knoll, and Whalers Cove areas. (Copyright 2002. Globe Explorer & Partners. All rights reserved.)

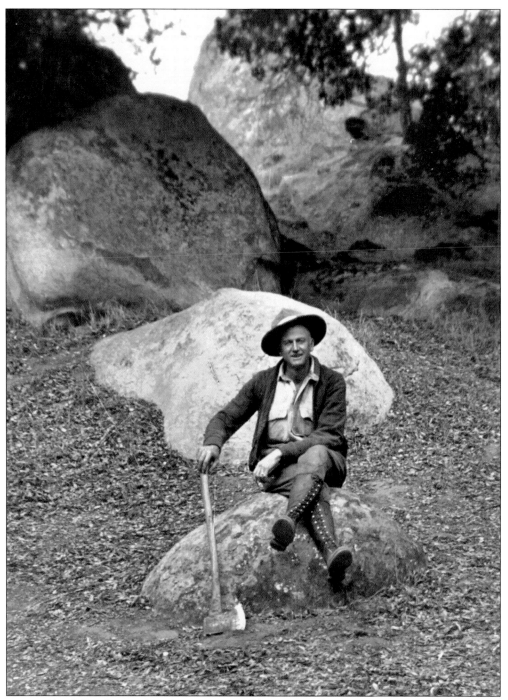

H. Lee Blaisdell, a forester by education, started his state park career in 1931 working to create the new Mount Diablo State Park. Frederick Law Olmsted Jr. had made recommendations for the layout of Point Lobos. Blaisdell was invited to work on the plan and he supervised the digging of the trails. This 1933 photo shows him with his ax, taking a break, resting on a granite boulder. (Robert K. Blaisdell collection.)

Roland Wilson was the first ranger at Point Lobos in 1935. Before coming to Point Lobos, Ranger Wilson had helped prepare Big Basin and Diablo State Parks. Wilson's passion was the natural sciences, but he was a man of many other talents. During his time off in 1949, he helped hew all the redwood timbers used in the building of Hudson House. He painted as well, and the state published his watercolors in a book of Point Lobos wildflowers. He retired in 1955, after 20 years at Point Lobos. (Harrison Memorial Library.)

During World War II, the U.S. Army used Whalers Cove for landing craft training. These seven men were detached from Fort Ord as instructors at the diesel and gas marine engine school held at Point Lobos in the summer of 1943. The Whalers Cabin was used for quarters, and classes were held in the tents seen in the background. (Photo by Henry Naeve, courtesy of Harrison Memorial Library.)

Several 36-foot-long wooden LCPRs (Landing Craft, Personnel, Ramp) are moored to a floating dock at right while others are anchored in the cove. These boats were used to train personnel in the operation of landing craft used in amphibious landings. A test of the fire suppression system is in progress. (Harrison Memorial Library.)

From 1942 to 1944, a Long Range Radar Site, operated by the Army Air Corps, was located at Piney Woods. A coastal defense battery was also there with its observation post situated on Whalers Knoll. Here, at Piney Woods, personnel and supply trucks are parked, camouflaged by the canopy of the trees. (Harrison Memorial Library.)

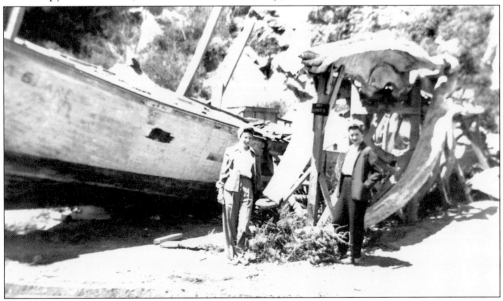

In the summer of 1943, wives were allowed to visit their husbands during special training at Point Lobos. Here the wives of Sgt. Henry Naeve and Sgt. Lloyd Meanor pose in front of the whale skeleton, moved from Cypress Grove to the present-day parking lot. Behind is the quarry, and to the left is what remained of the *Ida S.*, complete with a ladder to climb inside. The women are elegant in their slacks and the wartime fashion of scarves wrapping their hair. (Harrison Memorial Library.)

Four park rangers pose at San Jose Creek Beach along the northern boundary of Point Lobos. The personal expertise and dedication of rangers have benefited the many programs offered to the public. From left to right are the following: Jerry Loomis, Glen McGowan, Jim Carpenter, and Chuck Bancroft. Jerry, Glen and Chuck have spent most of their careers at Point Lobos State Reserve. (Photo by Chuck Bancroft.)

Every summer, the state parks offer a junior lifeguard program to introduce young people to water safety. The water along this part of the coast is about 55°F (13°C) year-round, making it necessary to wear a wet suit when swimming. This session is taught by a state park lifeguard at Point Lobos. It shows some of the participants, dressed in wet suits, putting into action what they have learned. (Photo by Chuck Bancroft.)

Jud Vandevere, a local biologist and teacher, worked for eight summers at the reserve as a naturalist. He was keenly aware of the need for knowledgeable people to explain the natural wonders of this unique area. He was a major catalyst for the formation of the current docent program. Here, in the early 1960s, Jud leads a group from the Sierra Club on an exploration along the inter-tidal zone at Point Lobos. (Photo by Jerry LeBeck.)

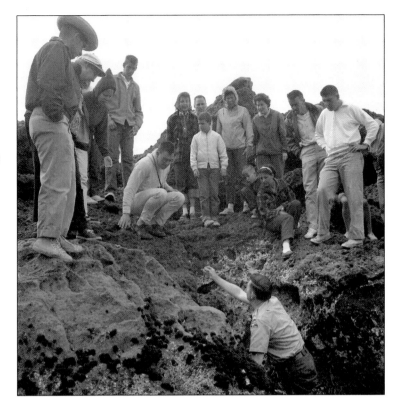

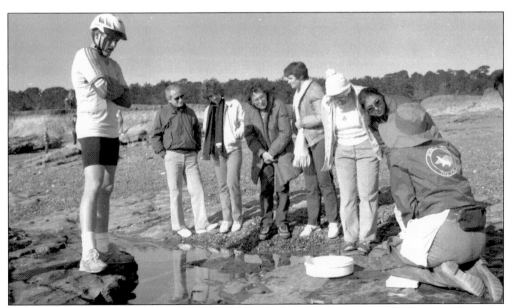

In 1981, a docent program was started to help explain the reserve's vital role in teaching the public the need for preservation. To enhance the visitor experience, there are currently 120 docent volunteers. Here docent Joy Osborne explains the intricate life of a tide pool to a group of fascinated visitors at Weston Beach. (Photo by Chuck Bancroft.)

To see the rugged beauty from the ocean, it is necessary to launch a small boat at Whalers Cove. In 1979, John Otter Jr. borrowed his father's sturdy canoe to take his two children for a sail in the cove. The fiberglass canoe had been outfitted by his father with a homemade outrigger, dagger board, and sail. To test its seaworthiness, John Otter Sr. successfully sailed this little craft from Point Lobos to Point Sur. (Jeannette Otter collection.)

In 1960, 750 acres of submerged land were added to Point Lobos State Reserve, creating the nation's first marine reserve. In 1973, it was dedicated as an ecological underwater reserve. A prime spot for scuba diving, this rich submarine region attracts divers from all over the world. Coming back from Blue Fish Cove, this team brings their inflatable rubber boat up the ramp at Whalers Cove. (Photo by Chuck Bancroft.)

This diver is discovering a whole new realm of beauty by gliding among the giant kelp forests. It is not uncommon for the curious California harbor seals to follow a diver on some of his explorations. To protect the fragile ecosystem, only a limited number of dive teams are admitted daily. (Photo by Jerry Loomis.)

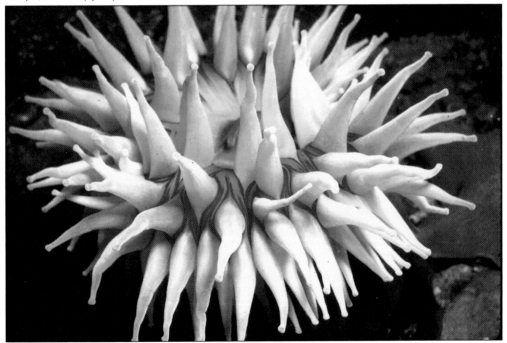

In the course of a dive at the reserve, it is possible to see a great variety of creatures and plants. One can observe underwater life in action, such as this flower of the sea, the anemone. It attaches itself to rocks, waits for food to swim by, stings the victim with its tentacles, and then wafts it into its mouth. (Photo by Jerry Loomis.)

In this early 1990s photo, longtime docent Carl Fulton staffs the information kiosk at the Cypress Grove parking area, where he assists visitors. Here Fulton uses a popular hands-on interpretive tool, the luxuriant pelt of a sea otter. A new and larger kiosk has replaced this one, but the function remains the same—to provide welcoming and helpful information to visitors to the reserve. (Photo by Chuck Bancroft.)

Docent Sister Anna leads a nature walk along the north side of Cypress Grove, where the granite cliff is naturally landscaped with beautiful wildflowers and succulents. In her retirement from teaching, Sister Anna shared her love for the natural sciences with thousands of school children and visitors. Her wildflower photography resulted in a poster that is a popular identifying tool and souvenir. (Photo by Chuck Bancroft.)

One of the major functions of the reserve is to teach children to appreciate the beauty of the natural world so that they will grow up to protect its resources. These two little children were having fun while learning; they were photographed in 1980 scrambling barefoot to catch up with their parents after a late-summer swim in the waters off Gibson Beach. (Photo by Craig Barth.)

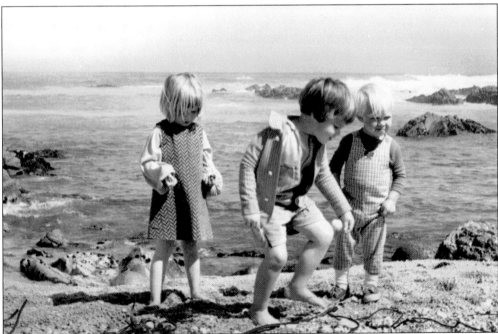

Here, curiosity and wonder are evident as Blase Mills, Ibi Janko, and Lars Rydell explore the shore near Weston Beach. The Rydell family made it their custom to start each new year with a visit to Point Lobos. They were often joined by local friends who appreciated the privilege of having this paradise at their doorstep. (Photo by Gull-Britt Rydell.)

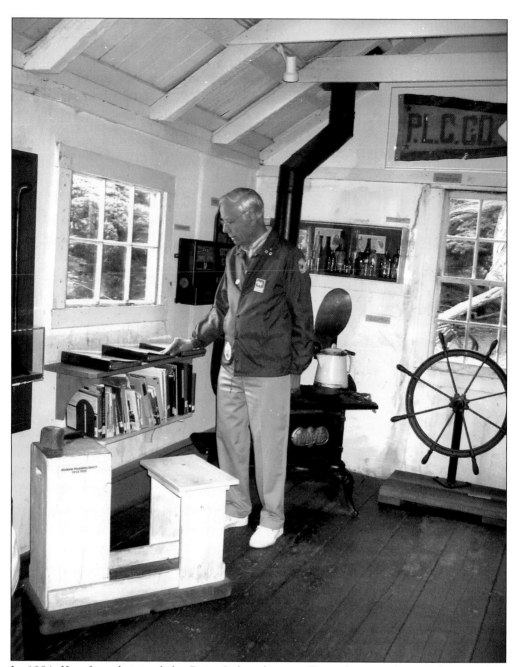

In 1984, Kurt Loesch joined the Point Lobos docents. From the start, he was fascinated by the untold story of the people who had lived there. Encouraged by supervising ranger Glen McGowan, he embarked on what would become a consuming quest to research Point Lobos' past. He spent years conducting personal interviews, library research, and tracking down photographs and artifacts. In 1989, his dream was realized when a museum devoted to Point Lobos' history opened its doors. Here, Kurt is shown inside the Whalers Cabin Museum. (Photo by Monica Hudson.)

Most of the photographs in this book have shown people, their work and play, their homes, and the ways they affected the land. For 100 years, people have visited Point Lobos to enjoy the scenery. We end this book with scenic photographs to remind us that Point Lobos will continue to be enjoyed by all. There are few places as beautiful, and Point Lobos, protected as a reserve, will remain an inspiration for generations to come. (Photo at right by Harold A. Short, 1958; bottom photo by K.B. Ninomiya.)

When approaching the point of Cypress Grove from the north, it is a surprise to see the trail ascend these granite steps. They could be footsteps to heaven guarded by an old, gnarled, and windswept Monterey cypress tree at the top. The breathtaking view that lies beyond may well be the closest thing to heaven one can imagine. (Photo by Craig Barth.)